ECOLOGICALS

BOTTLES
BOXES
BAGS

ECOLOGICALS BOTTLES BOXES BAGS

Copyright © 2015 Instituto Monsa de ediciones

Editor, concept, and project director
Josep María Minguet

Design and layout
Patricia Martínez (equipo editorial Monsa)

INSTITUTO MONSA DE EDICIONES
Gravina 43 (08930)
Sant Adrià de Besòs
Barcelona (Spain)
Tlf. +34 93 381 00 50
Fax.+34 93 381 00 93
www.monsa.com
monsa@monsa.com

Visit our official online store!
www.monsashop.com

Follow us on facebook!
facebook.com/monsashop

ISBN: 978-84-15829-82-9
D.L. B 867-2015
Printed by Cachimán Grafic

ECOLOGICALS
BOTTLES
BOXES
BAGS

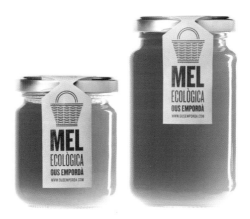

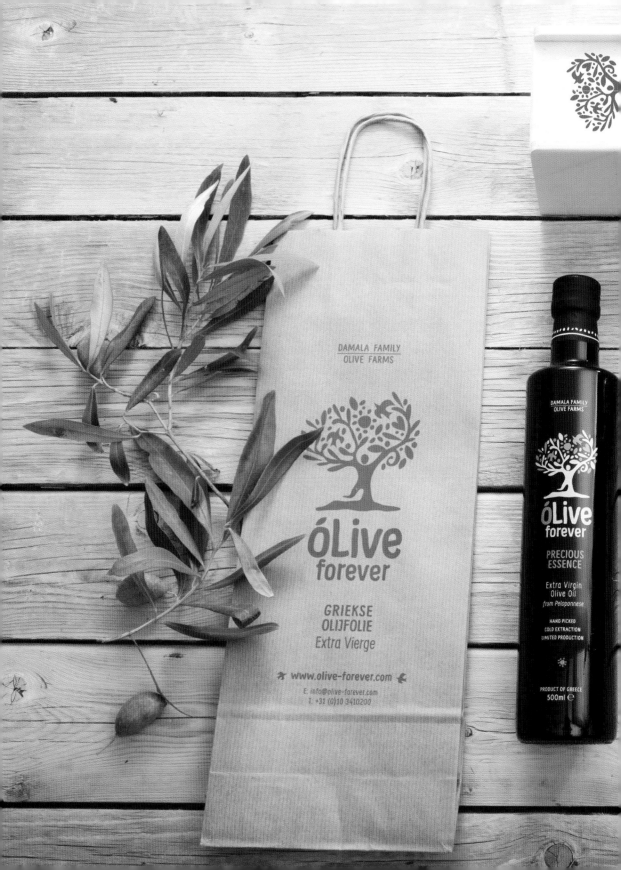

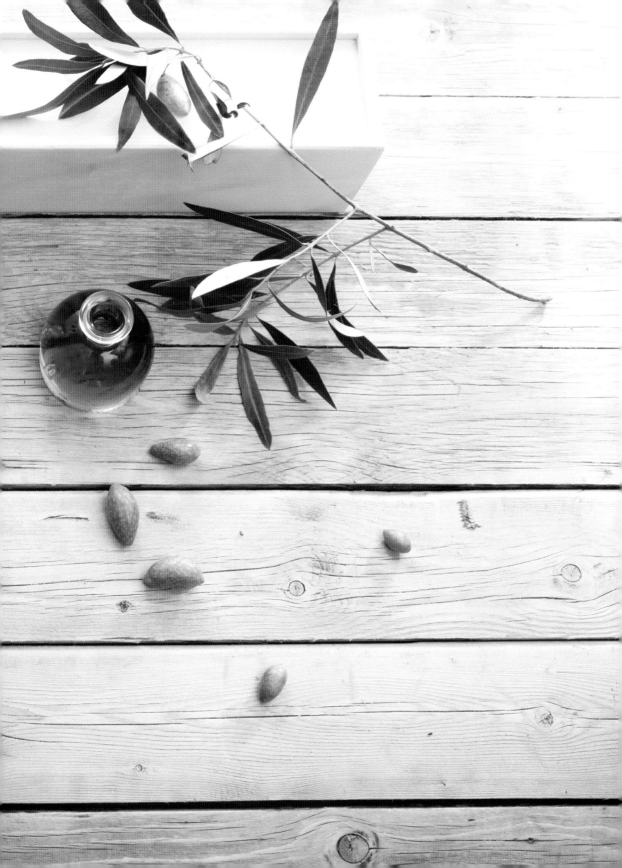

Studios
In alphabetical order

Alexander Pogrebniak
Olive Oil, 88

Emily Zirimis
App design & Packaging design for
Remra, 42

Alejandro Figueredo
Alejo, 54

Erick Fletes
Semilla, 26

António João Policarpo
Hotel's Flavour Route, 34

Erma Miller
Organic Hills Bags, 142

Blue Q
Nate Williams, 128

Filter017 Creative
Concept shop paper bag, 138

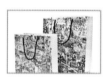

Can Cun
Postal Snacks, 57
Ecoproductes de Gallecs, 100

G280
La borsa, 124
La pasta storia, 126

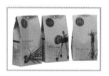

Ciclus
Pack for a bouquet, 36
Pack for the BAKUS mats, 40
Zen Winebag, 110

H-57 Creative Station
Coca-Cola HBC Italia, 16

Javier Garduño Estudio de Diseño
Calma Chicha, 28
Castro Mendi, 70

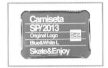

Sophia Georgopoulou
Home by Nature, 48, 98
Nutty Bunny, 52. Lepanto, 92
Olive Forever, 94. Fabrika, 122

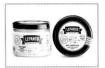

Lin Shaobin
Puer Tea, 27

TBWA/SMP
Bad Air Monster Bags, 136

Nueve Estudio
Cooperativa de Planes, 12, 74
Burgeronomy, 14

Tena Letica
Tote Bags for Kordon Blu, 114

Pepe Gimeno Proyecto Gráfico
El Corral de Saus, 72

The Creative Method
Sumo Salad packaging, 32
Obi Probiotic Soda, 62
OVI Hydration, 66

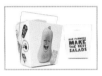

Petra Penz
Bäckerei Koch, 130
Gourmandiserie, 132
Queens, 134

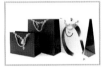

Thinketing
Slow, 139
Stop&Go 2008, 140

Prompt Design
Johnnie Walker Gift Wrap, 116

Toormix
Antiplastic Bags, 129

Senyor Estudi
Ous Empordà, 44
Abellaires Empordanesos, 77
Mel Ecològica, 82
Oju! Vinagre de vino, 84

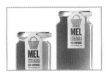

Zoo Studio
Cacao Barry, 20
Rubén Álvarez, 68

Serse Rodríguez
No tenim 2 planetes, cuida'l, 120

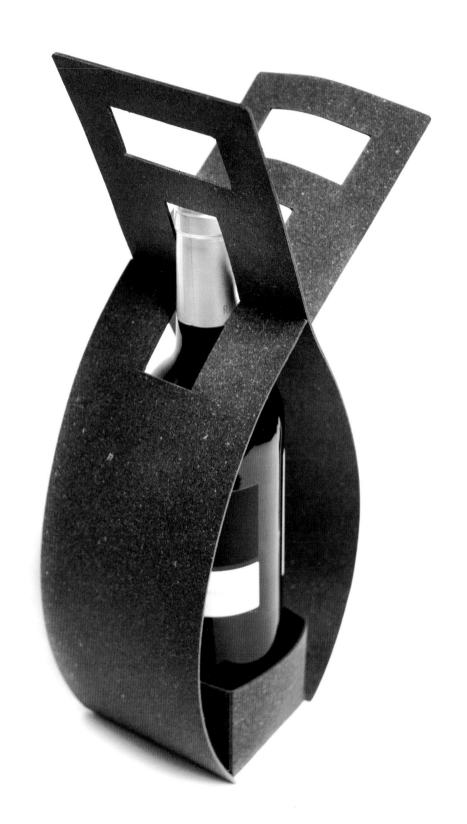

Introduction

The commitment to the environment and our planet, increasingly punished by pollution and climate change, leads us to be more responsible with the waste we generate in our daily life, and to have more responsibility in some production processes. Natural forests are replanted and felling is controlled to ensure that paper is produced from sustainable plantations using eco-friendly 100% raw materials and safe production methods.

Containers which are mostly produced are designed to be recycled later and increasingly it goes further in this sense: not only recyclables appear, but also biodegradable, packaging made from previously recycled material, or designed to give them a other use later.

Also in the food sector is increasingly important product of proximity (so-called Km 0) and organic production. In this sense there are small companies limited production such as honey, canned vegetables, eggs … looking for a package according to the product, to forward the same values. In this book three chapters are presented: "Boxes" Boxes fabricated from cardboard, paper pulp reusable aluminium, wood… "Bottles" In this chapter all types of packaging appear in which glass is the main material, and where we have also included some water bottles whose original design is converted into works of art. And finally "Bags"; Bags made of cardboard but also cotton, recycled leather, and in some cases fabricated from recycled plastic. All are reusable. In conclusion, designer containers for all types of products which have one thing in common: their commitment to the environment, to our climate.

El compromiso con el medio ambiente y nuestro planeta, cada vez más castigado por la contaminación y el consiguiente cambio climático, nos lleva a ser más responsables con los residuos que generamos en nuestro día a día, así como a tener mayor responsabilidad en algunos procesos de producción. Los bosques se replantan y se crean cultivos de árboles para su posterior uso industrial, se usan métodos no agresivos para la composición del papel y el cartón, y se emplean cada vez más materiales 100% ecológicos y reciclables.

Los envases que se producen en su mayoría están pensados para poder ser reciclados posteriormente, y cada vez se va más allá en este sentido: aparecen envases no sólo reciclables, si no también biodegradables, realizados con material previamente reciclado, o bien pensados para darles un uso distinto posteriormente.

Así mismo en el sector de la alimentación cada vez tiene más importancia el producto de proximidad (denominado de Km 0) y la producción ecológica. En este sentido existen pequeñas empresas de producción limitada tales como de miel, conservas vegetales, huevos… que buscan un envase acorde con el producto, que transmita los mismos valores.

En este libro se presentan tres capítulos: "Boxes" Cajas fabricadas en cartón, pasta de papel, aluminio reusable, madera… "Bottles" En este capítulo aparecen todo tipo de envases en los cuales el vidrio es el material protagonista, y donde hemos incluido también algunas botellas de agua cuyo original diseño las convierte en obras de arte. Y finalmente "Bags"; Bolsas en cartón pero también en algodón, piel reciclada, y algunos casos fabricadas en plástico reciclado. Reutilizables todas ellas. En resumen, envases de diseño para todo tipo de productos que tienen una cosa en común: su compromiso con el medio ambiente, con nuestro entorno.

Chapter 1

BOXES

Camiseta
SP/2013
Original Logo

Calma Chicha
SkateboardProductions

Red&White XL

Skate&Enjoy

Facebook.Com/CalmaChichaSb Youtube.com/CalmaChichaSb

For the development of the design, the orography of the Planning zone is strategically taken as the story line, as it is a distinguishing feature, regarding other co-operatives, and gives characteristics to their food and agriculture products which make them unique. The graphics and packaging of the products they offer should show in an honest manner both its origin, a co-operative in the Alicante mountains, and it's manufacture methods, using traditional growing techniques.

Para el desarrollo de la propuesta, se tomó estratégicamente como hilo argumental la orografía de la zona de Planes, puesto que es un punto diferenciador de ésta respecto a otras cooperativas y hace que sus productos agroalimentarios tengan unas características que los hacen únicos. La gráfica así como el packaging de los productos que ofrecen, debían exponer de manera honesta tanto su procedencia, una cooperativa de las montañas de Alicante, como su manera de hacer, la utilización de técnicas de cultivo tradicionales.

Cooperativa de Planes

client: Cooperativa de Planes
studio: Nueve Estudio
designer: Ana V. Francés, Cristina Toledo
Valencia, Spain
www.n-u-e-v-e.com

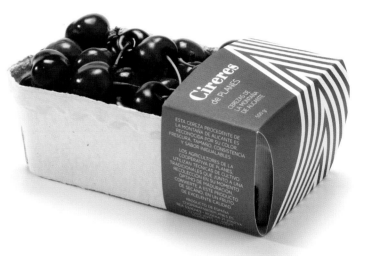

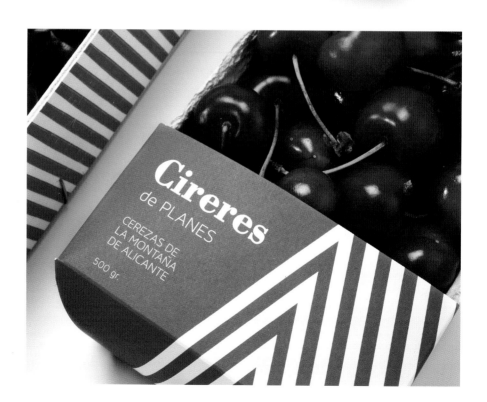

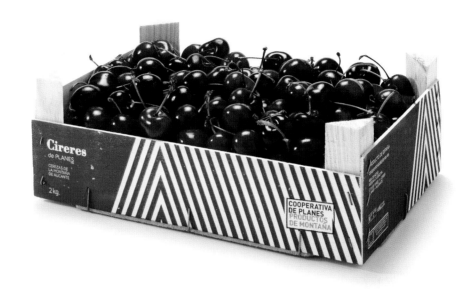

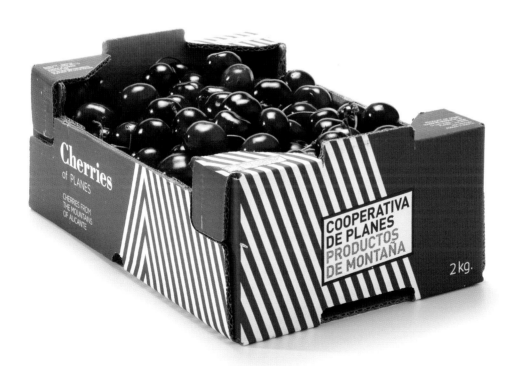

Burgeronomy, a burger restaurant chain from Saudi Arabia asked us to review their brand image and packaging. Its naming, which references an invented science, gave us the idea of creating their own language based on symbols inspired by the menu in offer.

Burgeronomy, una cadena de hamburgueserías de Arabia Saudí, nos encargó revisar su imagen y packaging. Su *naming*, en el que se hace referencia a una ciencia inventada, nos dio pie a crear su idioma propio a base de símbolos inspirados en el menú que ofrecen.

Burgeronomy

client: Burgeronomy
studio: Nueve Estudio
designer: Ana V. Francés, Cristina Toledo
Valencia, Spain
www.n-u-e-v-e.com

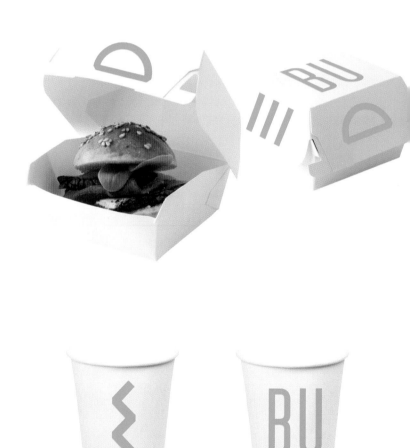

BURGERONOMY

برجرونومي

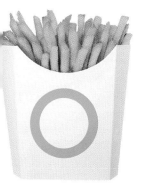

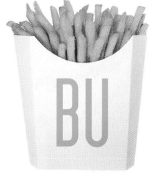

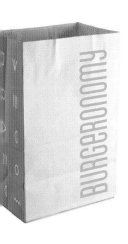

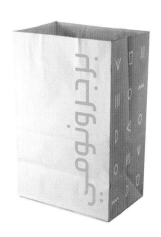

Coca-Cola HBC Italia

client: Coca-Cola HBC Italia
studio: Agency H-57 Creative Station
Milan, Italy
www.h-57.com

The brief was to find an eco-friendly packaging for the brochure that Coca-Cola HBC Italia dedicates every year to everything they do in terms of sustainable development. The idea was to recycle an existing object taken from the industrial process of bottling Coca-Cola and use it instead of throwing it away.

The final choice was to use defective PET pre-forms (which are the plastic object that, once inflated, become real bottles). All the pre-forms with some kind of fault were recycled and used to contain the brochure, so that the packaging itself could show the attention Coca-Cola HBC Italia gives to respecting the environment.

The defective PET pre-forms were gathered from the italian bottling plants of Coca-Cola and used to contain the brochure, which has been projected with the right dimensions to be rolled up and inserted in the pre-form. 6,500 units of the packaging were produced and delivered to to journalists, universities, associations, local and national authorities, mass retailers and competitors. The national press and trade reviews showed a great interest in the project and appreciation for Coca-Cola HBC Italia's concern about sustainable development. The local authorities as well as the employees of the plants and their families were involved in a series of events to improve even more the attention to social and environmental issues.

El encargo consistía en encontrar un envase ecológico para el folleto que Coca-Cola HBC Italia dedica cada año a todo lo que hacen relacionado con el desarrollo sostenible. La idea era reciclar un objeto existente creado a partir del proceso industrial de embotellamiento de Coca-Cola y utilizarlo en lugar de tirarlo.

La opción final fue usar unos moldes de PET, el plástico que, una vez inflado, se convierte en botellas de verdad. Todos los moldes con algún tipo de defecto fueron reciclados y se utilizaron para contener el folleto. De este modo, el propio envase mostraba la importancia que Coca-Cola HBC Italia le da al medioambiente.

Los moldes de PET defectuosos se recogieron de las plantas de embotellamiento italianas de Coca-Cola y se emplearon para contener el folleto, que se diseñó con las medidas adecuadas para enrollarlo y meterlo en el molde. Se produjeron 6500 unidades de envases y estas fueron entregadas a periodistas, universidades, asociaciones, autoridades locales y nacionales, minoristas y a la competencia. La prensa nacional y las críticas comerciales mostraron un gran interés en el proyecto y reconocieron la preocupación de Coca-Cola HBC Italia por el desarrollo sostenible. Las autoridades locales, así como los trabajadores de las plantas y sus familias, participaron en una serie de eventos para captar aún más la atención en temas sociales y medioambientales.

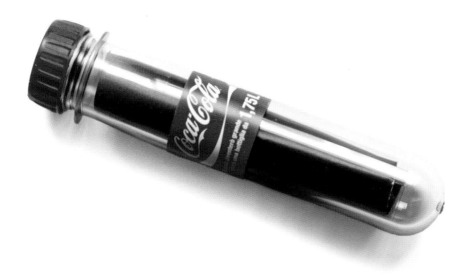

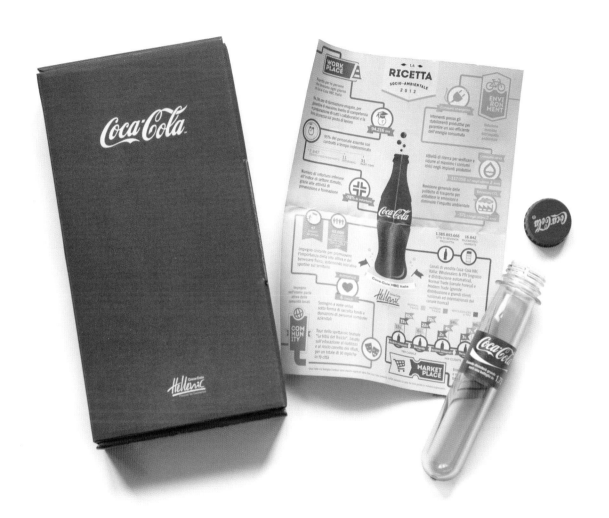

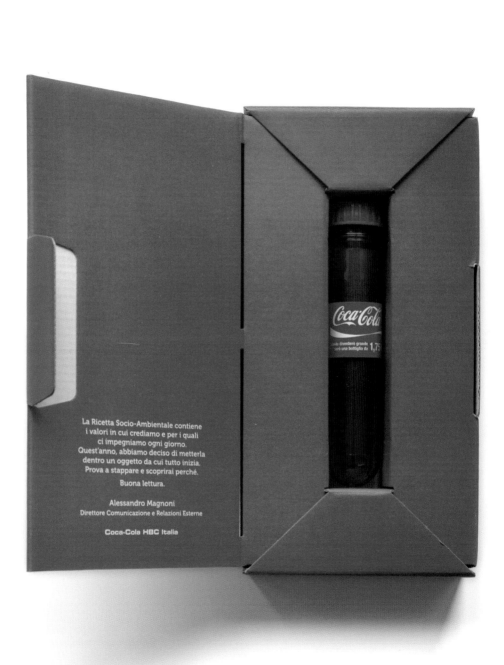

La Ricetta Socio-Ambientale contiene
i valori in cui crediamo e per i quali
ci impegniamo ogni giorno.
Quest'anno, abbiamo deciso di metterla
dentro un oggetto da cui tutto inizia.
Prova a stappare e scoprirai perché.

Buona lettura.

Alessandro Magnoni
Direttore Comunicazione e Relazioni Esterne

Coca-Cola HBC Italia

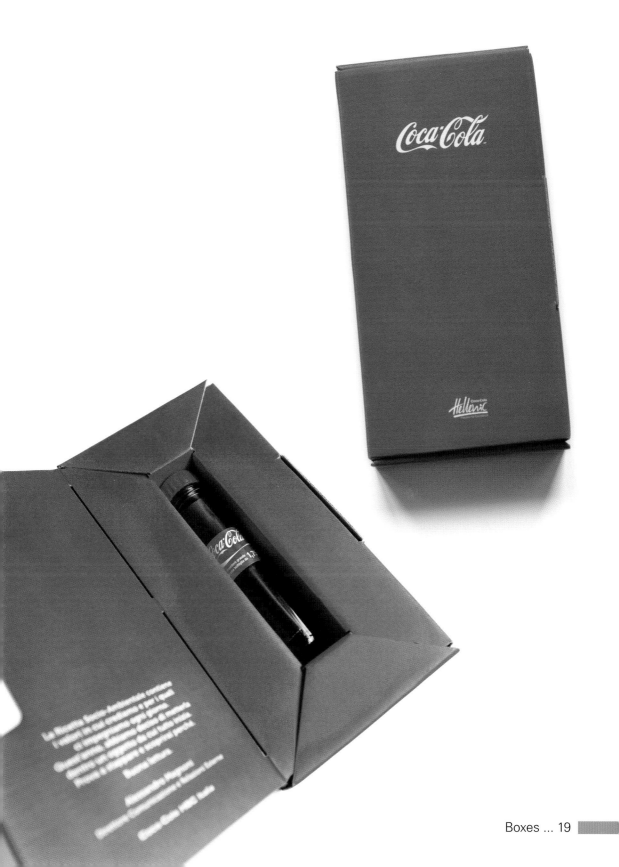

Design of a tray inspired by the fermentation drawers of the cocoa. The chocolates are put on a methacrylate that allows the cocoa beans to be seen. The presentation show was at night, and the box was equipped with LED lights that backlight the cocoa.

Diseño de una bandeja inspirada en los cajones de fermentación del cacao. Los bombones se sobreponen en un metacrilato que permite ver los granos de cacao. La presentación era nocturna y la caja se equipó con luces led que retroiluminan el cacao.

Tray Cacao Barry

client: Cacao Barry
studio: Zoo Studio
Vic, Barcelona, Spain
www.zoo.ad

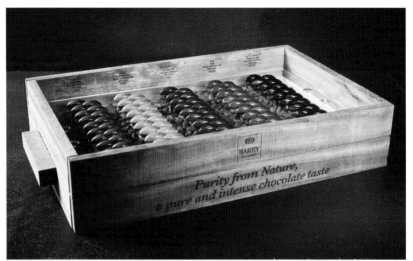

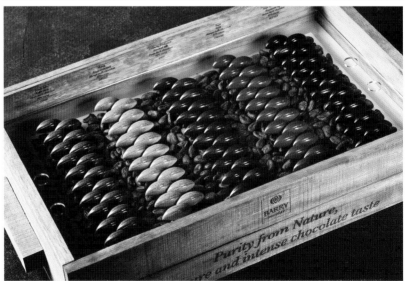

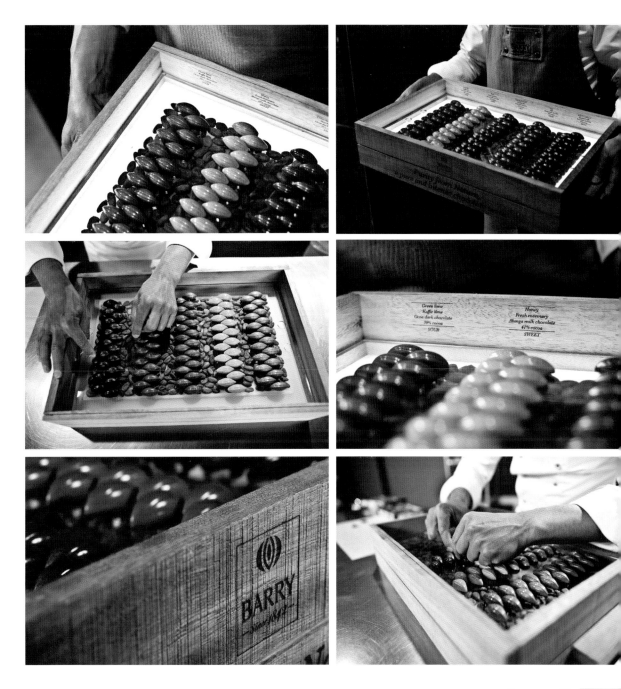

The chocolates in the image show labels reading:

Green lime
Kaffir lime
Ocoa dark chocolate
70% cocoa
SOUR

Honey
Fresh rosemary
Alunga milk chocolate
41% cocoa
SWEET

BARRY
Since 1842

Tocantins is a chocolate that comes from small cocoa plantations from the Amazon delta. The production is limited and reserved exclusively to the "World's 50 Best Restaurants". The packaging for the presentation is made with paper paste, tied with fine rope and sealed with sealing wax, evoking a remote origin with a band that provides exclusivity.

Tocantins es un chocolate que proviene de unas pequeñas plantaciones de cacao en el delta del Amazonas. La producción es limitada y reservada exclusivamente a los "World's 50 Best Restaurants". El packaging para la presentación es de pasta de papel cerrado con cordel y lacre, evocando a un orígen remoto, la faja le aporta exclusividad.

Cacao Barry | Trocantins

client: Cacao Barry
studio: Zoo Studio
Vic, Barcelona, Spain
www.zoo.ad

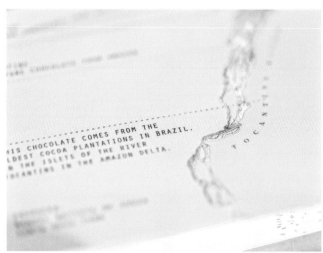

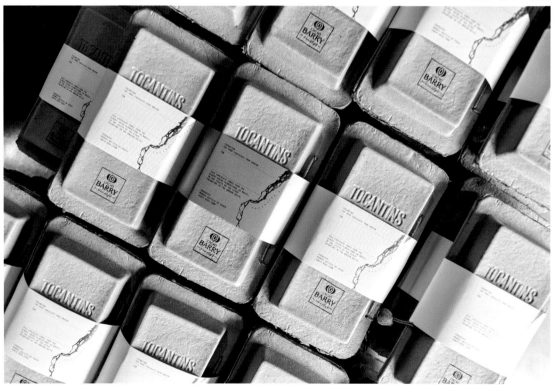

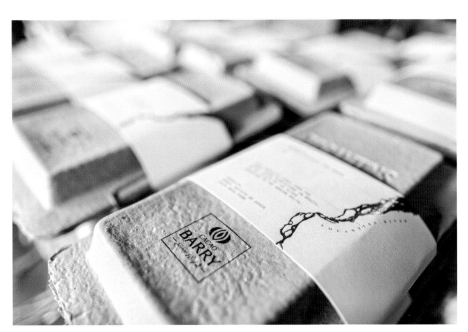

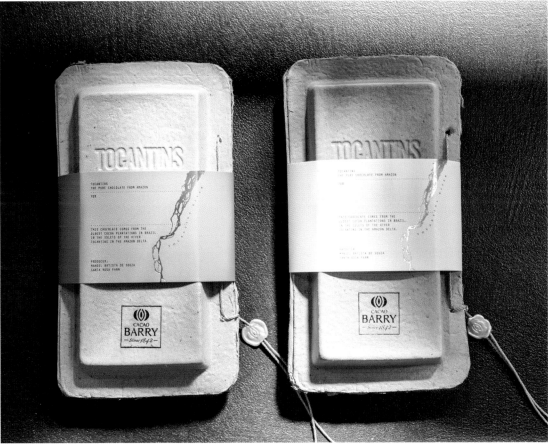

 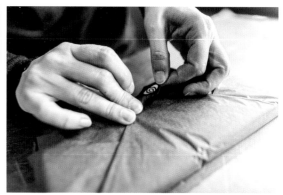

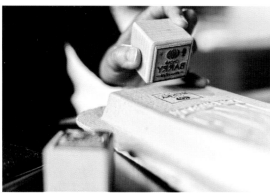 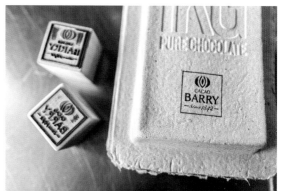

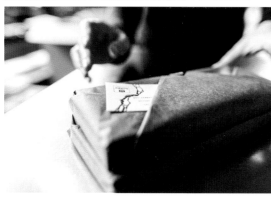 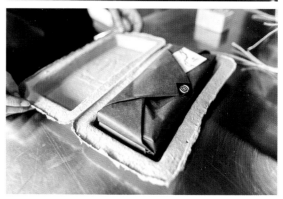

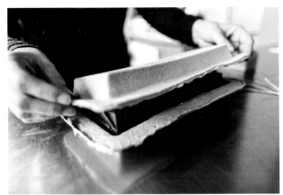
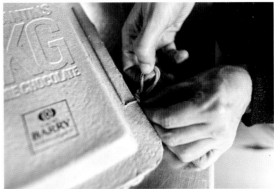
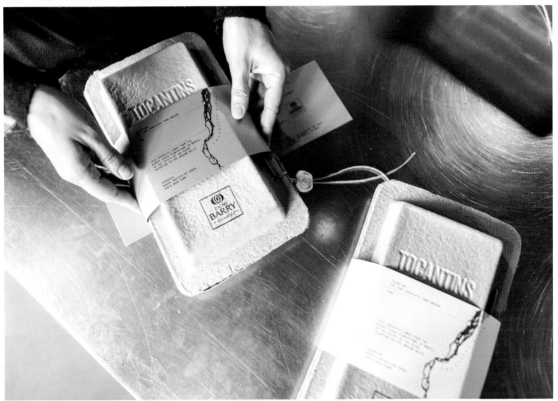
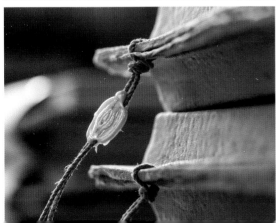

Semilla encompasses the fundamental values of recycling. In this time of sustainability and light treading of our planet we have come to face a new challenge, a challenge to create wisely with proper respect to the planet we live on. These garden seed packages are aimed at the demographic who live in a busy city and do not have a large plot, the individual pods come six to a package, just enough to grow the right amount of veggies. Soy based inks were also used as to not harm the planet in any way.

Semilla abarca los valores fundamentales del reciclaje. En estos tiempos de sostenibilidad y suave apisonamiento de nuestro palenta, nos encontramos delante de un nuevo reto: el reto de crear sabiamente respetando el planeta en el que vivimos. Estos paquetes con semillas de jardín están dirigidos a la población que vive en una gran ciudad y no tiene un gran terreno. Hay 6 vainas individuales en cada paquete, lo justo para cultivar las verduras suficientes. Se han utilizado tintas de soja para no dañar el planeta de ningún modo.

Semilla

client: Semilla
studio: Erick Fletes
designer: Erick Fletes
San Francisco, USA
www.oherick.com

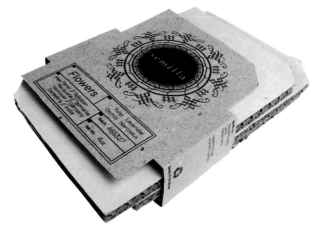

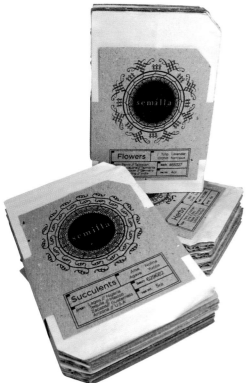

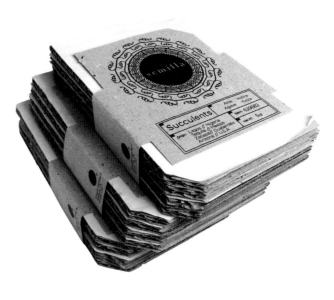

Puer tea

client: Gumachadao Puer tea
designer: Lin Shaobin
Shantou, China

The tea, the horse and the auspicious cloud constituted the main body of design, caucusing the human to associate to the horse caravan fable on the Ancient Tea Horse Road, and associates to glorious history of the Puer tea. The design took the ruby red as the host tone, symbolizing the noble unique quality tea soup of the Puer tea.

El té, el caballo y la nube prometedora constituyen el cuerpo principal del diseño, con asociaciones a la fábula de la caravana de caballos de la antigua Ruta del Té y los Caballos y a la gloriosa historia del té Puer. El diseño incorpora el rojo rubí como tono principal, que simboliza la noble calidad del té Puer.

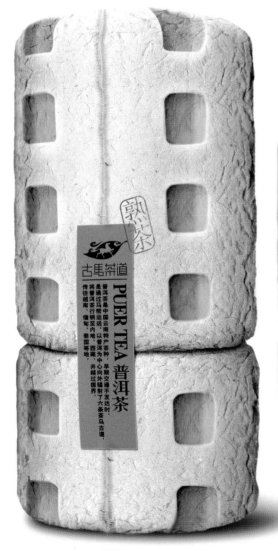

Calma Chicha is a group of skaters with artistic interests to which we belong. For the sale of the shirts we decided to make a packaging which is economic, everyday and original. For it we chose some aluminium containers for prepared food, and we designed some lids made of recycled card-board with the colour of each shirt to make identification easier. The result is an original and cheap packaging which everyone keeps. Skate and enjoy! Winners of GOLD in the PREMIOS INSPIRA 2014 for design in the packaging category.

Calma Chicha es un colectivo de skaters con inquietudes artísticas al cual pertenecemos. Para la venta de las camisetas decidimos hacer un packaging que fuera económico, cotidiano y original. Para ello escogimos unos recipientes de aluminio donde va la comida preparada, y diseñamos unas tapas de cartón reciclado con el color de cada camiseta para facilitar la identificación. El resultado es un packaging original, barato y que todo el mundo guarda. Skate and enjoy! Ganadores del ORO en los PREMIOS INSPIRA 2014 de diseño en la categoría de packaging.

Calma Chicha

client: Calma Chicha Skate Productions
studio: Javier Garduño Estudio de Diseño
Zamora, Spain
www.javiergarduno.com

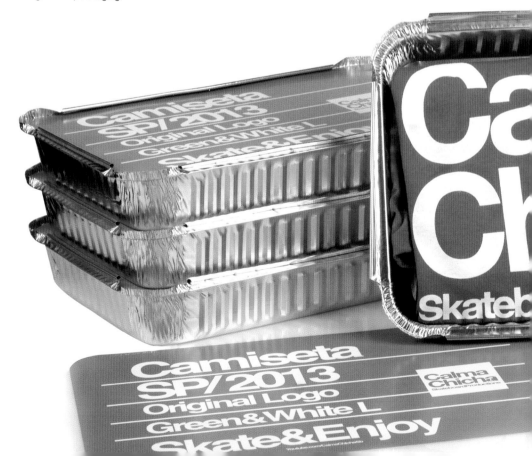

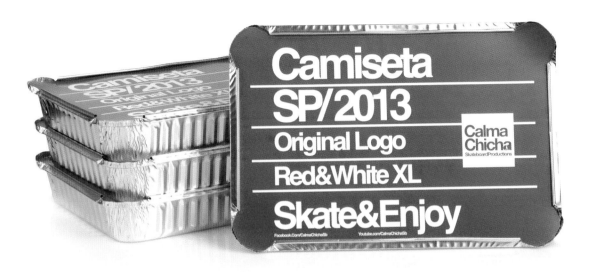

Camiseta
SP/2013
Original Logo
Red&White XL

Skate&Enjoy

Calma Chicha
SkateboardProductions

Facebook.com/CalmaChichaSb Youtube.com/CalmaChichaSb

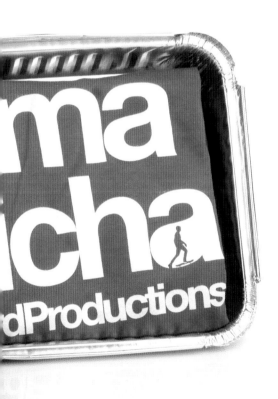

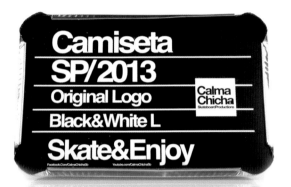

Camiseta
SP/2013
Original Logo
Black&White L

Calma
Chicha
SkateboardProductions

Skate&Enjoy

Facebook.Com/CalmaChichaSb Youtube.com/CalmaChichaSb

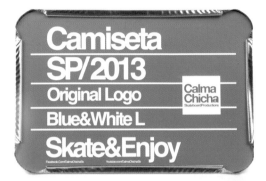

Camiseta
SP/2013
Original Logo
Blue&White L

Calma
Chicha
SkateboardProductions

Skate&Enjoy

Facebook.Com/CalmaChichaSb Youtube.com/CalmaChichaSb

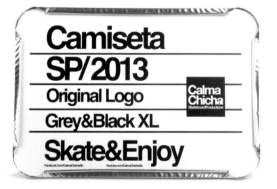

Camiseta
SP/2013
Original Logo
Grey&Black XL

Calma
Chicha
SkateboardProductions

Skate&Enjoy

Facebook.Com/CalmaChichaSb Youtube.com/CalmaChichaSb

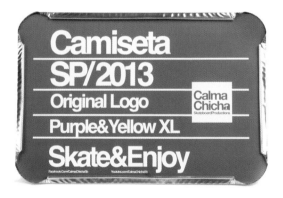

Camiseta
SP/2013
Original Logo
Purple&Yellow XL

Calma
Chicha
SkateboardProductions

Skate&Enjoy

Facebook.Com/CalmaChichaSb Youtube.com/CalmaChichaSb

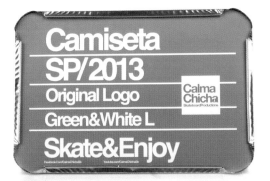

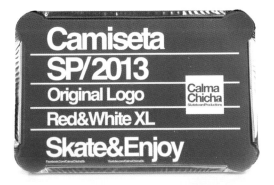

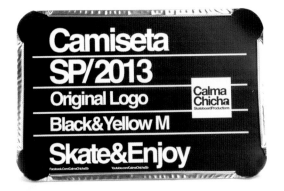

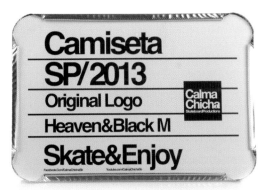

The brand leader in fresh salads
needed a fresh look at it's branding and
communications.
Australia's most successful salad chain
needed a design refresh. We were introduced
at a grass roots level to look at evolving the
strategy, core values and reason for being. We
initially produced a company manifesto and
once refined the job was to apply the thinking
into as many visual touch points as possible.
At the heart of the thinking was to drive a
greater sense of freshness, connection to the
farmers and community and create a unique
language and approach to a big brand.
The branding and subsequent packaging
looks to give personality and attitude to the
ingredients. This creates a strong impact
and cut through but also drives warmth and
personality to what is a big corporate brand.
There are a number of different boxes, each
featuring a different hero ingredient and a
benefit oriented copy line.

La marca líder de ensaladas frescas
necesitaba renovar su imagen y sus
comunicaciones.
La cadena de ensaladas con más éxito de
Australia necesitaba actualizar sus diseños.
Nos enseñaron las bases de la empresa
para que desarrolláramos la estrategia, los
valores esenciales y su razón de ser. Primero
hicimos un manifiesto corporativo y, una vez
perfeccionada la tarea, se aplicaron dichas
ideas en todos los puntos visuales posibles. Lo
esencial de la idea era transmitir una mayor
sensación de frescura, la relación con los
granjeros y la comunidad, y crear un lenguaje
y un enfoque únicos en una gran marca.
La creación de la marca y sus subsiguientes
envases pretenden dar personalidad y actitud
a los ingredientes. Esto genera un fuerte
impacto y va directo al grano, pero también
aporta calidez y personalidad a una gran
marca corporativa.
Hay una variedad de cajas distintas y cada
una de ellas tiene un ingrediente protagonista
distinto.

Sumo Salad Packaging

client: Sumo Salad
studio: The Creative Method
designers: Tony Ibbotson & Tim Heyer
creative director: Tony Ibbotson
finisher art: Tim Heyer
illustrator: Tim Heyer
Sydney, Australia
www.thecreativemethod.com

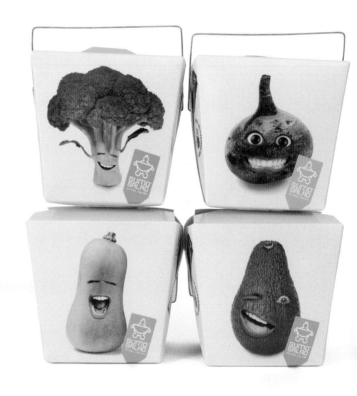

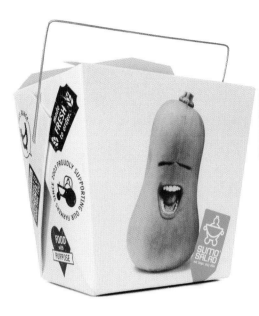

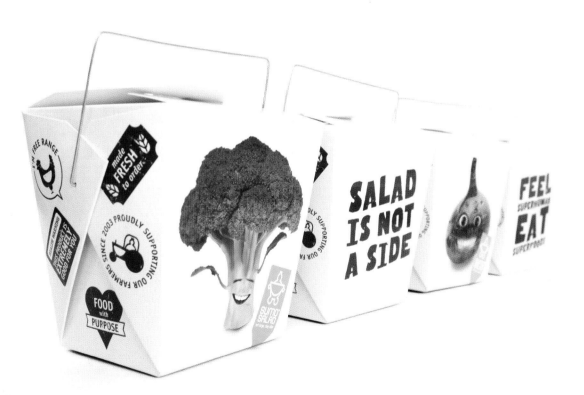

Hotel's Flavour Route

client: Boa Boca
idea / concept / design: António João Policarpo
photo: António João Policarpo
Évora, Portugal
www.policarpodesign.com

This range of product were conceived for the Hotels, with 5 small boxes, with 5 different flavours, sweet and salty, and that was the idea of name of the products. The colours are strong and design is very simple. The small window allow to show the product. All together they form a very attractive combination.

Está línea de productos fue concebida para los hoteles, con cinco cajitas y cinco sabores distintos, dulce y salado. Con esta idea se puso nombre a los productos. Los colores son fuertes y el diseño, muy sencillo. El producto puede verse por la ventanita. Todo junto forma una combinación muy atractiva.

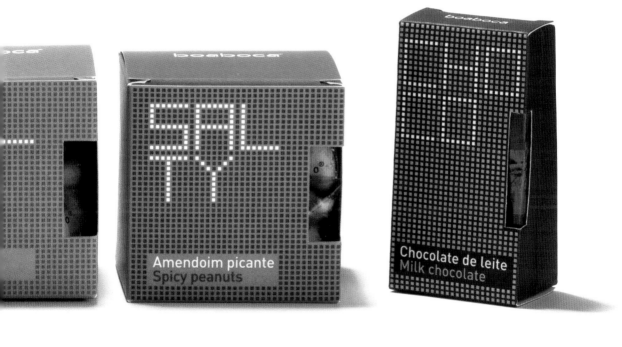

Pack for a bouquet of flowers

client: Tulipia
studio: Ciclus
designer: Tati Guimarães
Barcelona, Spain
www.ciclus.com

The packaging is a modern retake of the old straw baskets for flowers but it's weave is in the form of a garden lattice. The idea was, through these concepts, to bring a sensation of life to the fresh air. Another important feature is that the packaging is multifunctional and, after using it as packaging, it can be converted into a vase, lamp, plant pots, pedestals and other things.

The packaging is made with a minimum amount of materials and processes; and with the aim of generating the maximum amount of sensations and functions. The lids are made from 100% recycled plastic and the rest of the packaging is made from 100% recycled compact cardboard which all comes from a single mould (basket, handle, part to fit the doors with water and label).

The packaging is delivered flat to facilitate and minimise transport and delivery. The assembly is also easy to facilitate use.

El packaging es una relectura contemporánea de los antiguos cestos de paja para llevar flores pero su trama tiene la forma de celosías de jardín. La idea fue, a través de estos conceptos, traer la sensación de la vida al aire libre. Otro punto importante es que el packaging es multifuncional y, después de su uso como embalaje, se convierte en jarrón, lámpara, platitos para macetas, pedestal y otros.

El packaging esta hecho con el mínimo de materiales y procesos; y con el fin de generar el máximo de sensaciones y funciones. Las tapas están hechas en plástico 100% reciclado y el resto del embalaje esta hecho en cartón compacto 100% reciclado y sale toda de un sólo troquel (cesto, asas, pieza para encajar los puertos con agua y etiqueta).

El packaging se entrega en plano para facilitar y minimizar el transporte y el almacenaje. También es de fácil montaje para facilitar el manipulado.

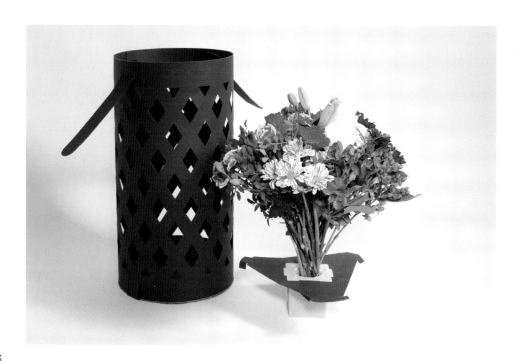

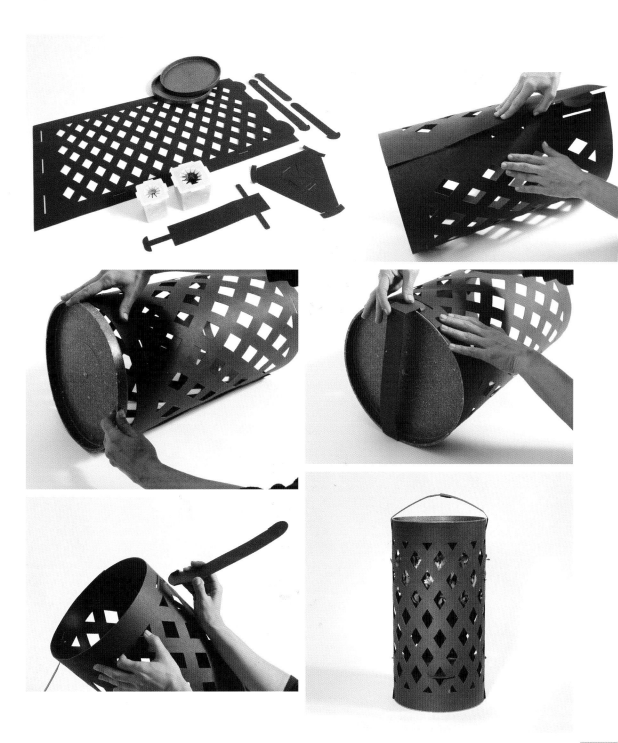

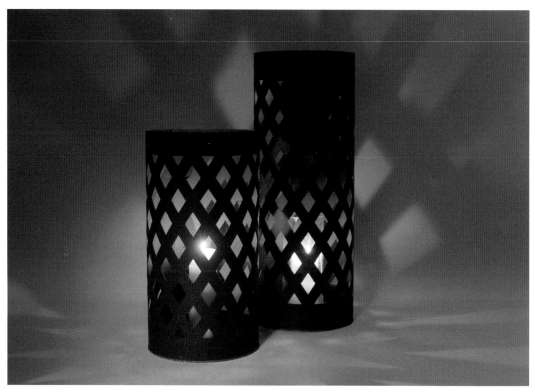

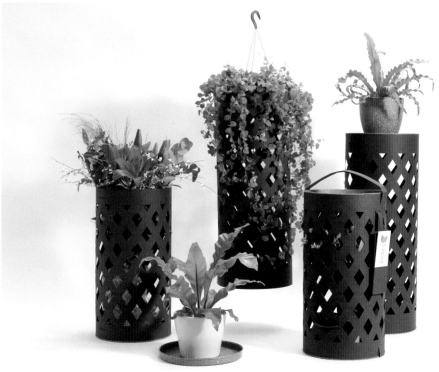

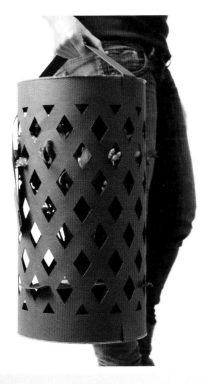

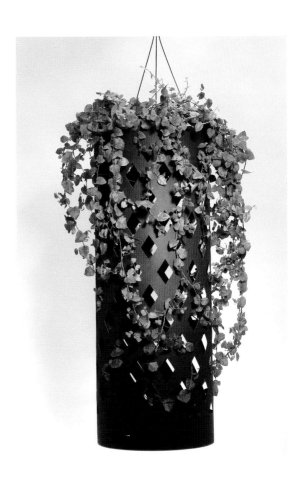

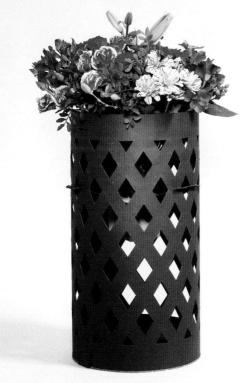

Packaging for the BAKUS mats

client: MoMA (Museum of Modern Art of New York)
studio: Ciclus
designer: Tati Guimarães
Barcelona, Spain
www.ciclus.com

The packaging is inspired by the object itself: BAKUS, a collector of best moments (wine corks) converted into table mats. It should be as original as the product, and transmit it's concept. The idea was to generate the surprise of receiving a "precious object".
The closing and inner shape of the packaging are inspired by the triangular points of the product (BAKUS).
The material used is a 100% recycled micro-groove cardboard. This packaging has been designed with the minimum amount of materials and processes: without glue and without complicated fittings - to facilitate it's production and handling.

El packaging esta inspirado en el propio objeto: BAKUS, un coleccionador de mejores momentos (corchos de vino) que se convierte en un salvamanteles. Debería ser tan original como el producto, y transmitir su concepto. La idea fue generar la sorpresa de recibir un "objeto-joya".
El cierre y las formas interiores del packaging están inspiradas en los pinchos triangulares del producto (BAKUS).
El material utilizado es un cartón micro-canal 100% reciclado. Este packaging ha sido diseñado con el mínimo de materiales y procesos: sin pegamento y sin encajes complejos - para facilitar su producción y manipulado.

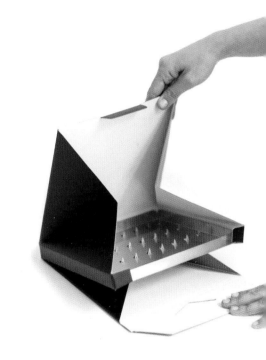

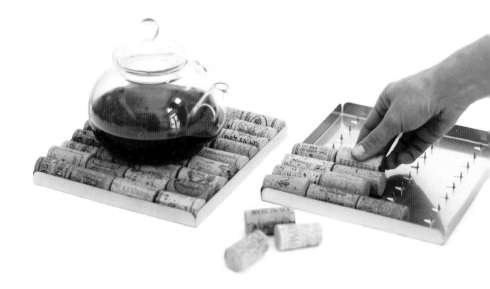

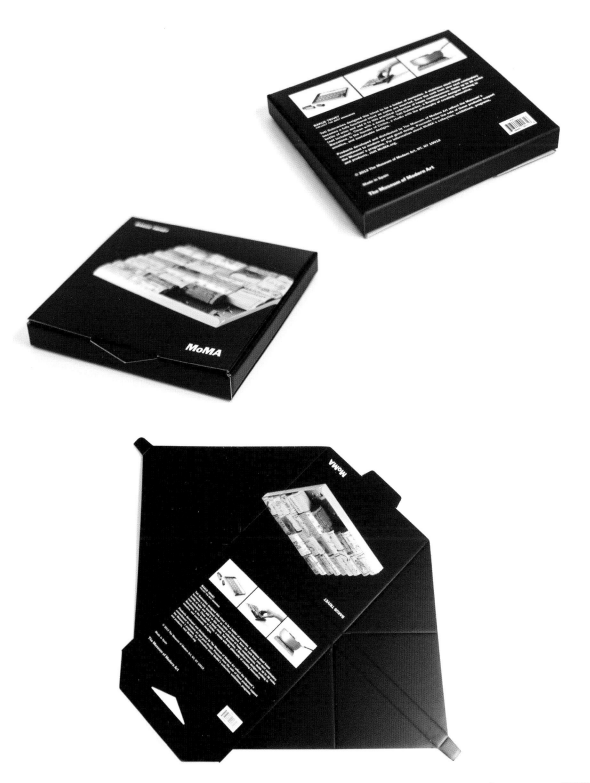

App Design & Package Design

client: Remra
designer: Emily Zirimis
New York, USA
www.behance.net/ezirimis

Remra is sensory reminiscence therapy.
When a certain sense sends you right back to a certain time, place or date with a specific person, you can use Remra to quickly record simple facts about this visceral memory, so that it is not forgotten.
This app is meant to organize and preserve these sensory memories. Archive those triggers and those moments when you are placed in your past again. Document them, keep track of your triggers to go back to later. Reminiscing is healthy for you, and this app keeps your triggers in one place to reflect back on.
Also included is the sensory reminiscence kit which coincides with the app. The kit contains five items that pertain to each of the five senses. A blanket, which alludes to touch, a custom made mug and tea, which alludes to taste, a room spray, which alludes to scent, a playlist [that can be downloaded online] which alludes to sound, and an air plant, which alludes to sight.
In addition, the kit contains a journal and two pens to write about your memories as you so please, and a guidebook that goes into more detail about the benefits of sensory reminiscence therapy.

Remra es una terapia de recuerdos sensoriales.
Cuando un sentido determinado te lleva directo a un momento, un lugar o una fecha concretos con una persona concreta, puedes utilizar Remra para grabar rápidamente datos simples sobre ese recuerdo visceral y que nunca se olvide.
Esta aplicación pretende organizar y conservar estos recuerdos sensoriales, archivar aquellos momentos que te llevan de nuevo al pasado. Puedes documentarlos y seguirles la pista para recuperarlos más tarde. Recordar es algo saludable y esta aplicación mantiene tus recuerdos en un mismo sitio para luego reflejarlos.
También incluye el kit de recuerdos sensoriales, que va acorde con la aplicación. Este juego contiene cinco artículos que se corresponden con los cinco sentidos: una manta para el tacto, una taza personalizada y té para el gusto, un ambientador para el olfato, una lista de reproducción (que puede descargarse en línea) para el oído y una planta epífita para la vista.
Además, el kit contiene un diario y dos bolígrafos para que escribas tus recuerdos como quieras y una guía que te dará más detalles sobre los beneficios de la terapia de recuerdos sensoriales.

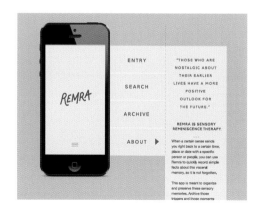

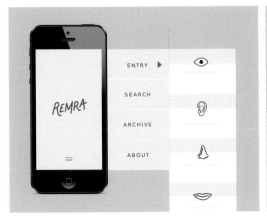
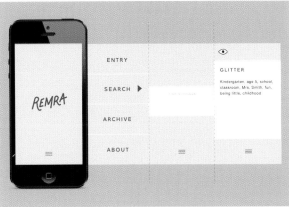

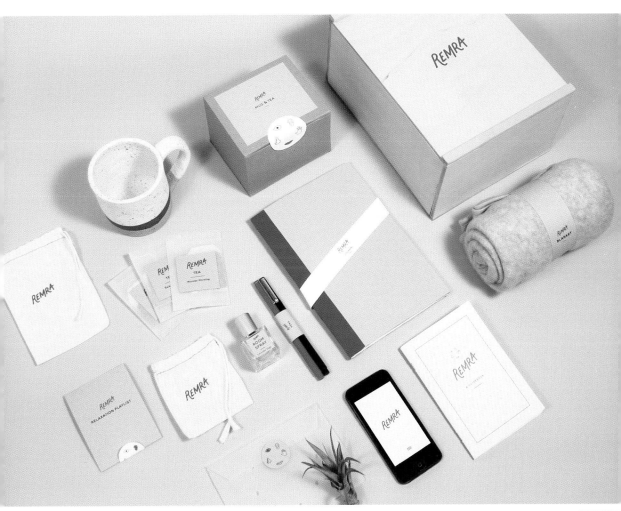

Rubber and eggs have always had a very close relationship. In the past, eggs were bought in bulk, and it wasn't until the final moment of the sale that they were packed into a simple case which was sealed with an rubber band, popularly named "chicken band". This name was acquired due to the fact that they were re-used bands, which were previously used to tie up, specifically, chicken's feet. The rubber band, is a very versatile object which - apart from being made from recycled rubber - can be re-used in multiple occasions. To close open pasta or vegetable packets, to make bunches of onions, to make a "slingshot"... Using coloured rubber, this packaging manages to captivate because, beyond it's principal function, it's components are re-used and are easily recycled.

La goma y los huevos siempre han tenido una relación muy estrecha. Antiguamente, los huevos se compraban a granel, y no era hasta el momento final de la compra cuando se empaquetaban dentro de un estuche sencillo que se cerraba con una goma elástica, popularmente llamada "goma de pollo". Había adquirido este nombre debido a que eran gomas reutilizadas, que previamente habían tenido su función para atar, precisamente, las patas de los pollos. La goma, es un elemento muy versátil que –a parte de ser producida con caucho reciclado– puede recobrar vida en múltiples ocasiones. Para cerrar los paquetes abiertos de pasta y legumbres, para hacer manojos de cebollas, para hacer un "tirachinas"... Utilizando gomas de colores, este pack pretende seducir porque, más allá de su función principal, se reutilicen sus elementos y sean fácilmente reciclables.

Ous Empordà

client: Ous Empordà
studio: Senyor Estudi
designers: Lluís Serra Pla, Mireia Sais Pelaez
Ventalló, Spain
www.senyorestudi.com

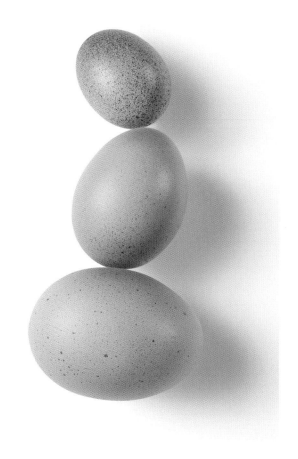

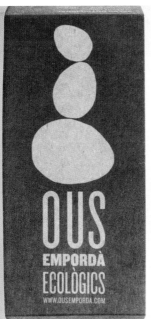

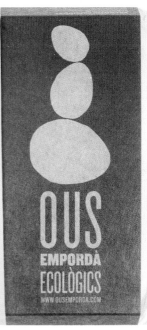

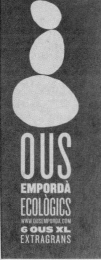

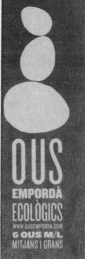
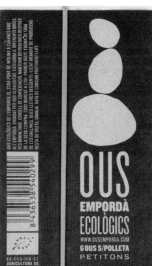

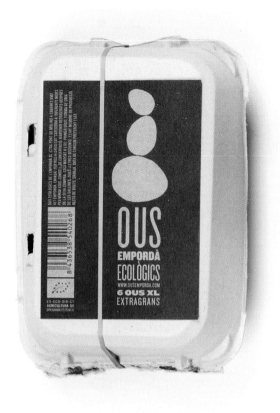

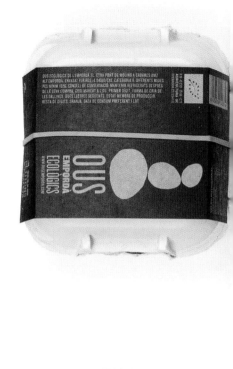

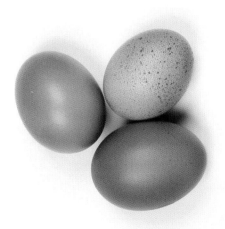

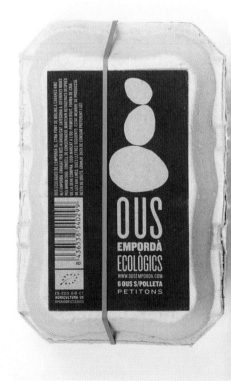

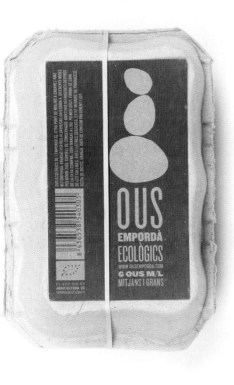

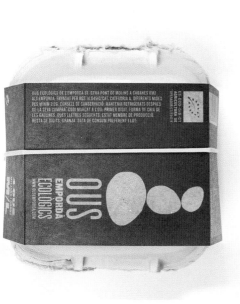

Home by Nature

client: Home by Nature Co.
studio: Sophia Georgopoulou | Design
Athens, Greece
www.sophiag.com

The brief was to create a brand identity for
a series of olive oils and other olive based
products with the potential to expand to other
goods in the future, beyond the food industry.
The target audience is Greek and foreign "health
conscious" costumers, people who value quality
in their everyday life.

El encargo consistía en crear una identidad
de marca para una serie de aceites de oliva
y otra para productos fabricados a partir de
la oliva con potencial para expandirla en el
futuro en otros artículos más allá de la industria
alimentaria. El público objetivo son los griegos y
clientes extranjeros preocupados por su salud,
gente que valora la calidad en su día a día.

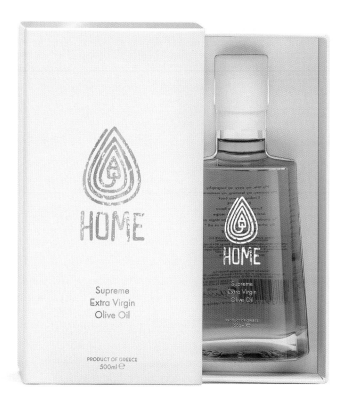

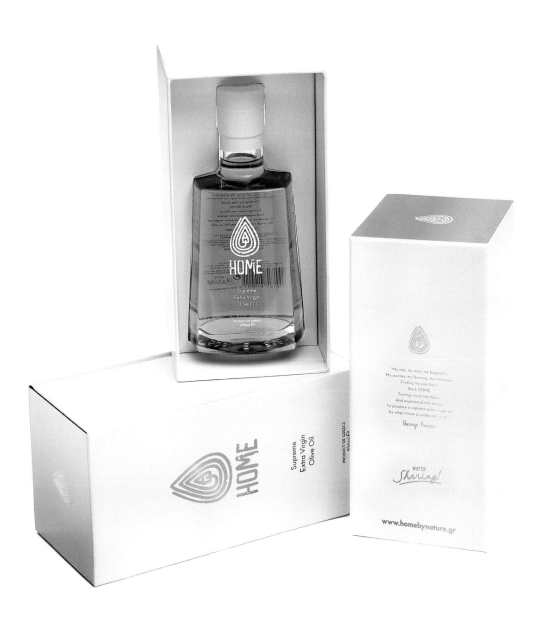

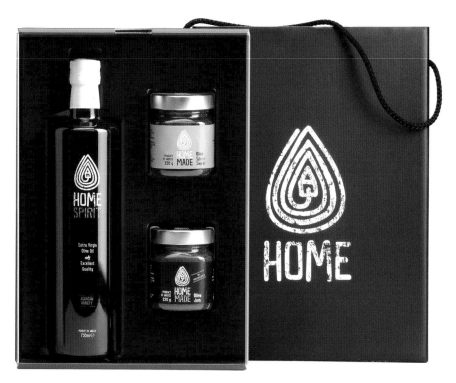

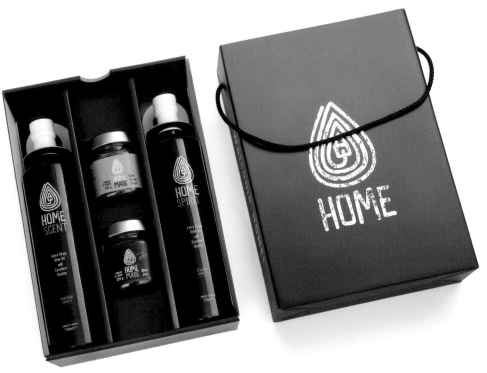

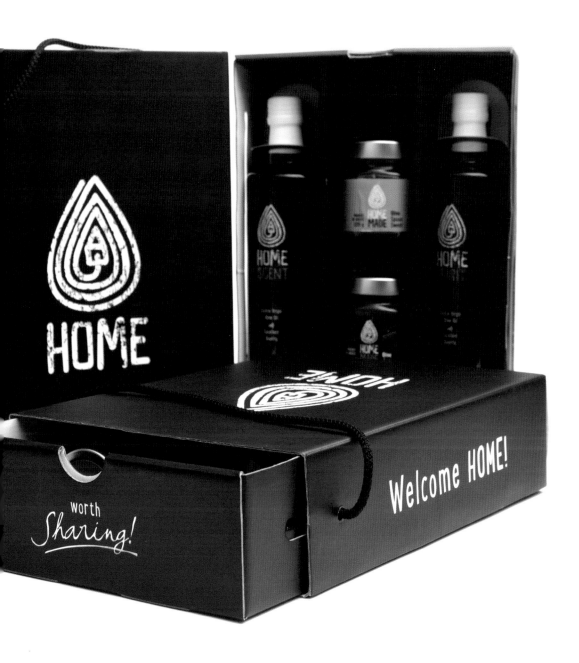

Nutty Bunny

client: Nutty Bunny LLC
studio: Sophia Georgopoulou | Design
Athens, Greece
www.sophiag.com

Nutty Bunny is a delicious handcrafted non-dairy frozen dessert and it is made with the purest ingredients on the planet!
Nutty Bunny products are made in small batches in Westport, Connecticut, United States. All ingredients are 100% organic, vegan, non-GMO and are naturally gluten-free. Nutty Bunny products do not use any artificial sweeteners and there are no funky, unpronounceable substances. They simply use nature's purest ingredients and local sources whenever possible.
The hand written whimsical logo with the hand drawn bunny and overall package design gives this product the hand crafted feel, reflecting what the product represents. It symbolizes purity, love & care, a child's innocence and the craving for dessert!
The color palette consists of pale colors – based in white, and the handmade font enhance the final end result.

Nutty Bunny es un delicioso postre helado sin lactosa que se produce artesanalmente y se hace con los ingredientes más puros del planeta.
Los productos Nutty Bunny se producen en pequeños lotes en Westport, Connecticut, Estados Unidos. Todos los ingredientes son cien por cien orgánicos, vegetarianos, no están modificados genéticamente y no contienen gluten de forma natural. Los productos Nutty Bunny no llevan ningún edulcorante artificial ni ninguna sustancia extraña e impronunciable. Simplemente se utilizan los ingredientes más puros de la naturaleza y los recursos locales siempre que se puede.
El enigmático logotipo escrito a mano con el dibujo de un conejito y el diseño general del envasado hace que este producto transmita la sensación de que es artesanal, y refleja lo que el producto representa. Simboliza pureza, amor, cuidado, inocencia infantil y ¡el antojo de comerse un postre!
La paleta cromática está formada por colores pastel, basados en el blanco, y la tipografía hecha a mano mejora el resultado final.

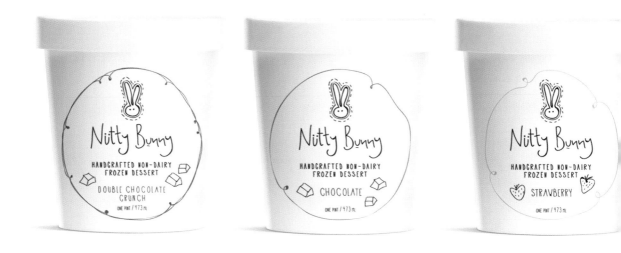

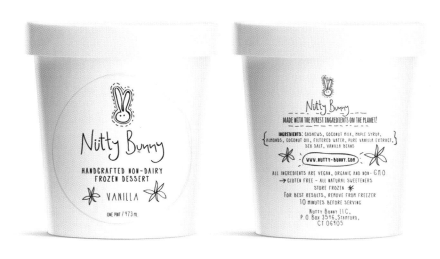

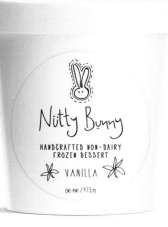

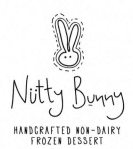

Alejo

studio: Alejandro Figueredo
designer: Alejandro Figueredo
Savannah GA, USA
www.cargocollective.com/alejandropf44

As human beings, first impressions are very important. Disrupting the routine is an easy way of making a concise impressions and create a long lasting memory. That is the idea behind the Bubblegum-business cards.

The point is creating a whole experience around the package and the interaction with it. When a business card is offered, the person immediately sees a small pack and will pick piece of "gum". Yet, instead of a piece of gum, all my contact information is on it. This is quite a surprise to the person as the gum wrapper has the feel and smell of real gum! Yes, even the distinct cinnamon smell! The reaction is always well received and it's usually a good ice breaker.

Every single detail on the package reflects the personality of the designer. The nutrition facts is represented with professional experience, the ingredients are the set of skills and the bar code is the phone number, everything made of FSC approved materials. You only have a chance for a first impression, why not make it unique?"

Como seres humanos, las primeras impresiones son muy importantes. Romper con la rutina es una manera fácil de dar una impresión concisa y crear un recuerdo duradero. Esa es la idea que hay detrás de las tarjetas de visita Bubblegum. La cuestión es crear toda una experiencia que gire alrededor del envase y la interacción con él. Cuando entregue una tarjeta de visita, la persona verá inmediatamente un envase y cogerá un chicle. Sin embargo, en vez de un chicle, lo que encontrará será todos mis datos de contacto. Esto le sorprenderá porque el envoltorio del chicle tiene el tacto y huele como un chicle de verdad. ¡Sí, tiene hasta el inconfundible olor a canela! La reacción siempre es positiva y suele ser una buena manera de romper el hielo.

Todos y cada uno de los detalles del envase reflejan la personalidad del diseñador. En la información nutricional está la experiencia profesional, los ingredientes son las aptitudes y el código de barras es su número de teléfono. Solo hay una oportunidad para dar una primera impresión. ¿Por qué no hacerla única?

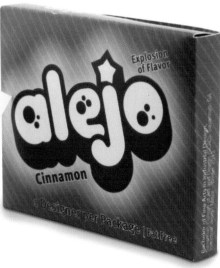

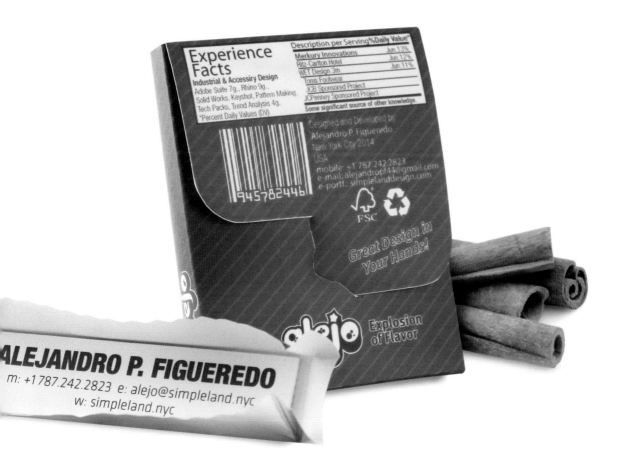

Experience Facts

Industrial & Accessory Design
Adobe Suite 7g., Rhino 9g.,
Solid Works, Keyshot, Pattern Making,
Tech Packs, Trend Analysis 4g.
*Percent Daily Values (DV)

Description per Serving	%Daily Value*
Merkury Innovations	Jun 13%
Ritz-Carlton Hotel	Jun 12%
WET Design 3m	Jun 11%
Toms Footwear	
JCB Sponsored Project	
JCPenney Sponsored Project	
Some significant source of other knowledge.	

Designed and Developed by
Alejandro P. Figueredo
New York City 2014
USA
mobile: +1 787.242.2823
e-mail: alejandropf444@gmail.com
e-port: simplelanddesign.com

FSC · recycle

Great Design in Your Hands!

alejo · Explosion of Flavor

945782446

ALEJANDRO P. FIGUEREDO
m: +1 787.242.2823 e: alejo@simpleland.nyc
w: simpleland.nyc

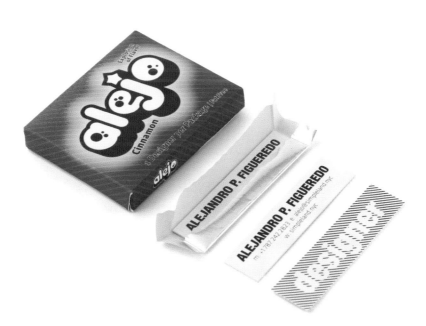

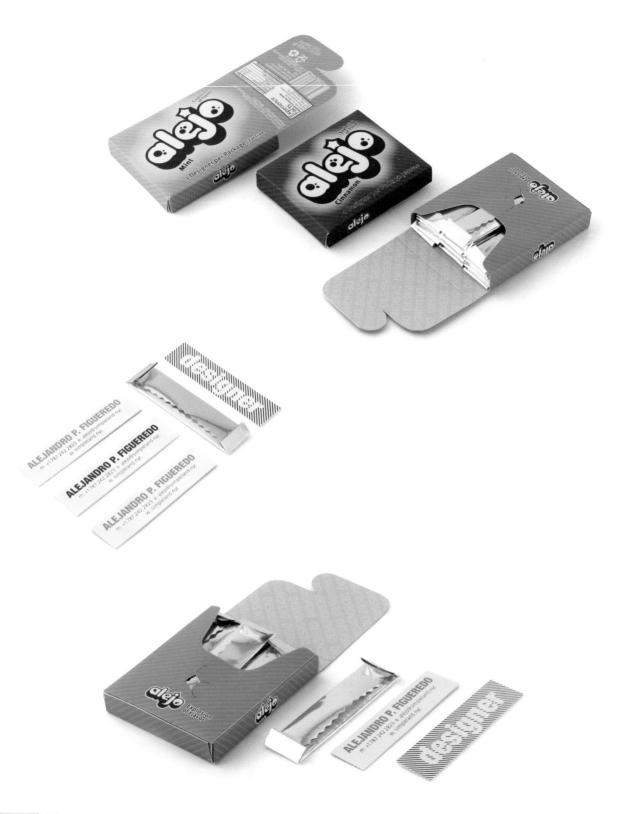

client: POSTAL SNACKS. Fruits secs i llaminadures ecològiques
studio: Can Cun
Granollers (Barcelona), Spain
www.fromcancun.com

Dried fruit and ecological sweets.
Conceptualisation and design of the Postal Snacks shop and products. The concept (postal) reinforces the idea of a variety of ecological products from everyone. By this motivation we can appreciate that we can not only buy online, but also give a friend or family member a packet of the product we like most as a gift, accompanied by a personalised postcard.

Frutos secos y golosinas ecológicas.
Conceptualización y diseño de la tienda y productos Postal Snacks. El concepto (correos) refuerza la idea de la variedad de productos ecológicos procedentes de todo el mundo. Por este motivo se puede apreciar que en la web no sólo se puede comprar, sino que también regalar un paquete del producto que más nos guste a un amigo o a un familiar, acompañado de una postal dedicada.

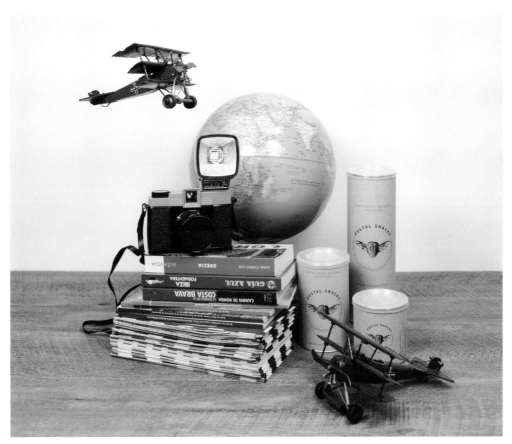

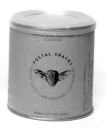

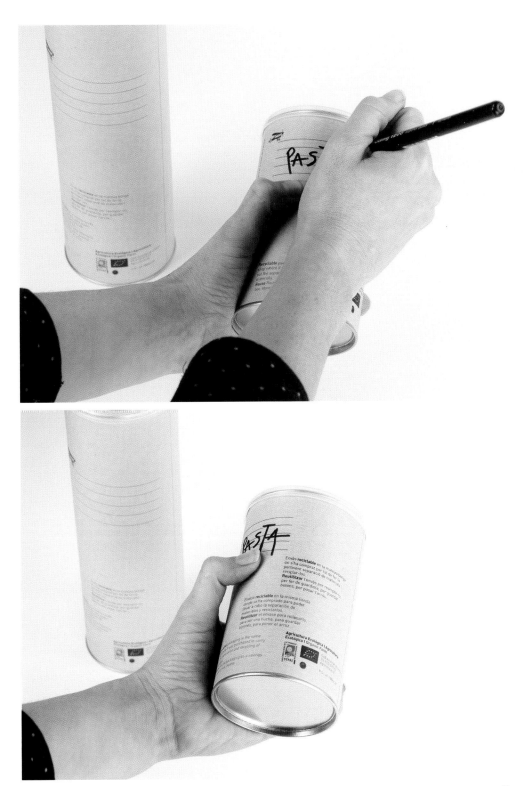

Chapter 2
BOTTLES

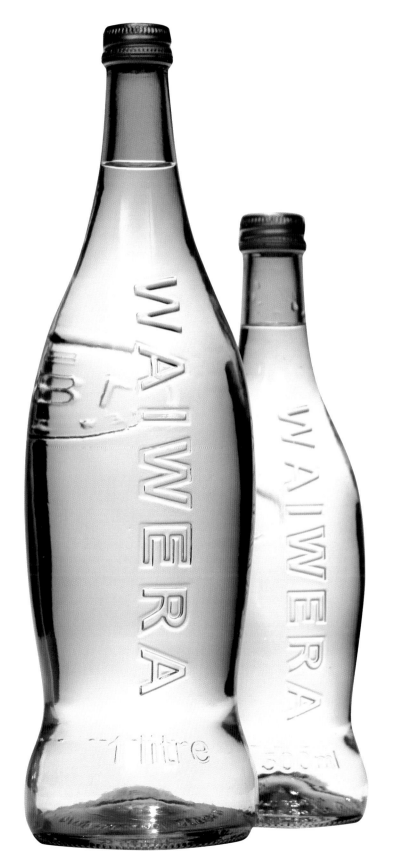

OBI could be one of the biggest innovations in the CSD market. A great tasting soda out of the USA that is also a probiotic which promotes healthy digestion and is low in sugar and fat. The holy grail of the billion dollar drinks industry. A responsibly sourced Probiotic Soda that is good for the environment as well as the consumer!

The brief was to bring together science, fun, nature and appetite appeal in a simple way. Being a start up it needed to have great shelf standout and quickly communicate the offer and benifits.

The solution uses scientific and biological circles to represent the live culture in the probiotic. These circles were shapped to reflect the main flavour of each variant and within this shape was place an image of the full ingredients designed to drive clearer communication and appetite appeal.

OBI podría ser una de las mayores innovaciones en el mercado de las bebidas carbonatadas. Se trata de un sabroso refresco estadounidense que también es probiótico, por lo que estimula una buena digestión y es bajo en grasas y azúcares. El santo grial de la multimillonaria industria de bebidas. Un refresco probiótico obtenido de forma responsable que es bueno para el medio ambiente y para el consumidor.

El encargo consistía en unir ciencia, diversión, naturalidad y apetito de una forma sencilla. Al tratarse de una empresa nueva, necesitaba llamar la atención en el estante y comunicar de forma rápida lo que ofrece y sus beneficios.

La solución incluye círculos científicos y biológicos que representan la cultura viva del producto probiótico. Las formas de estos círculos muestran el sabor principal de cada variedad y, dentro de esta forma, se puso una imagen de todos los ingredientes diseñada para transmitir una comunicación más clara y despertar el apetito.

Obi Probiotic Soda

client: OBI
studio: The Creative Method
designers: Tony Ibbotson & Tim Heyer
creative director: Tony Ibbotson
finisher art: Tim Heyer
illustrator: Tim Heyer
Sydney, Australia
www.thecreativemethod.com

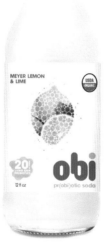
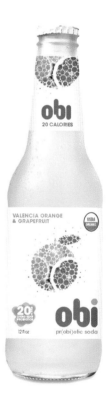

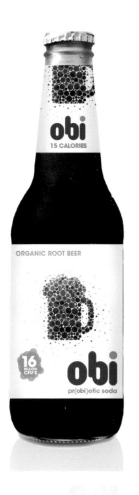
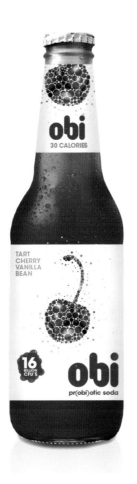
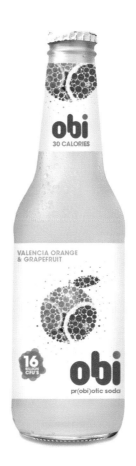
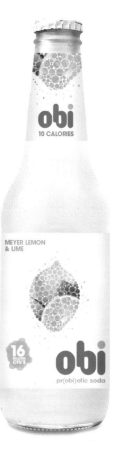

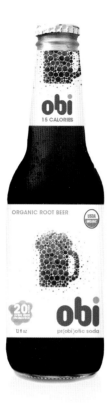

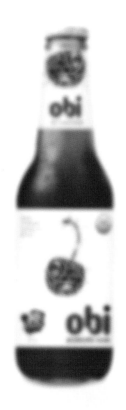

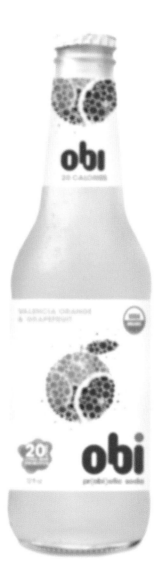

MEYER LEMON
& LIME

USDA
ORGANIC

20 KINDS OF SOME
LIVING KEFIR
PROBIOTICS

12 fl oz

obi
pr(obi)otic soda

The Creative Method was commissioned by
the Suntory team in Japan to design their
first soft drink ever to be sold in the Australian
market.
OVI is a new value-added beverage
containing green tea which was developed
jointly with the Frucor Group for the growing
Australian and global hydration drink market.
Carbonated drinks and beverages containing
fruit juice account for almost 70 percent of
Australia's soft drink market. The market has
been seeing demand for low-sugar, low-
calorie soft drink products pick up pace in step
with increasing consumer health awareness.
Aiming to appeal to health-conscious
consumers, the product was named OVI. It's a
combination of "Oh!," since it's surprisingly tasty
for a healthy drink, and "vie," the French word
for "life."
The simple package design features the OVI
logo on the front accompanied by illustrations
of cut fruits and tea leaves against the colors
that represent their flavors.

El equipo japonés de Suntory encargó a The
Creative Method diseñar su primer refresco
que se iba a vender por primera vez en el
mercado australiano.
OVI es una nueva bebida que contiene té
verde y que se desarrolló junto con el Grupo
Frucor para el creciente mercado de bebidas
hidratantes australiano y mundial.
Las bebidas carbonatadas con zumo de
fruta representan casi el 70 % del mercado
de refrescos de Australia. El mercado se ha
percatado de que la demanda de refrescos
bajos en calorías y azúcares ha cogido
el ritmo de los cada vez más numerosos
consumidores concienciados por su salud.
Con el objetivo de atraer a los consumidores
preocupados por su salud, el producto se
llamó OVI, una mezcla de «¡Oh!», porque
tiene un sorprendente sabor para ser una
bebida sana, y «vie», «vida» en francés.
El diseño sencillo del envase presenta
el logotipo de OVI en la parte delantera
acompañado de ilustraciones de frutas
cortadas y hojas de té que contrastan con los
colores que representan sus sabores.

OVI Hydration

client: Suntory
studio: The Creative Method
designers: Tony Ibbotson & Tim Heyer
creative director: Tony Ibbotson
finisher art: Tim Heyer
illustrator: Tim Heyer
Sydney, Australia
www.thecreativemethod.com

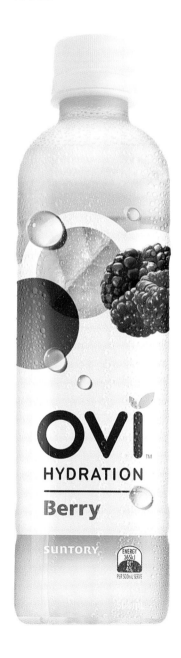

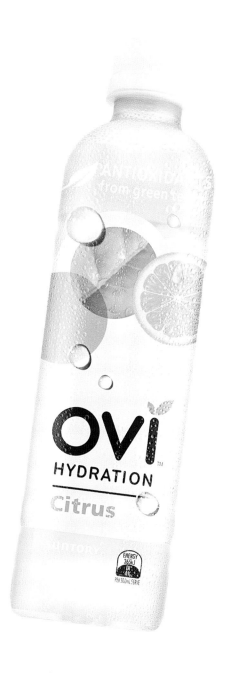
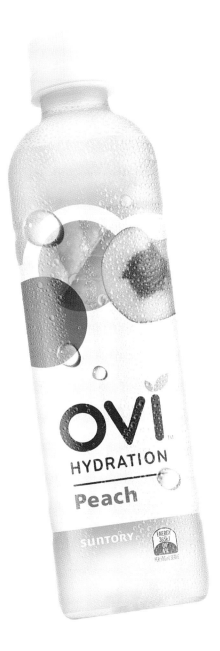

Packaging design for a new product by
chocolate maker Rubén Álvarez.
The glass jar is inside a cardboard packaging
with a laminated anti-damp paper inside with
an aluminium finish, sealed with a white wax.

Diseño de packaging para un nuevo producto
del chocolatero Rubén Álvarez.
El bote de vidrio está dentro de un envase de
cartón con un papel contraencolado en el
interior que es antihumedad con acabado de
aluminio, el sellado es lacre de color blanco.

Rubén Álvarez

client: Rubén Álvarez
studio: Zoo Studio
Vic, Barcelona, Spain
www.zoo.ad

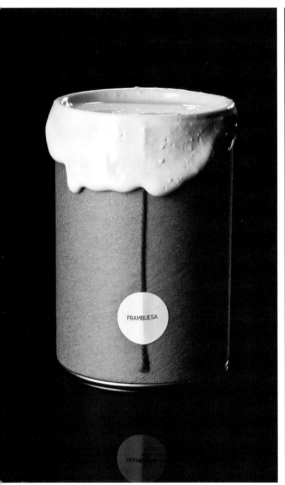

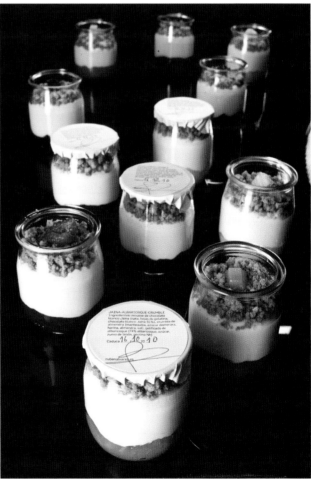

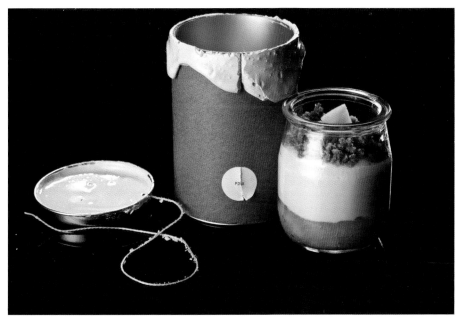

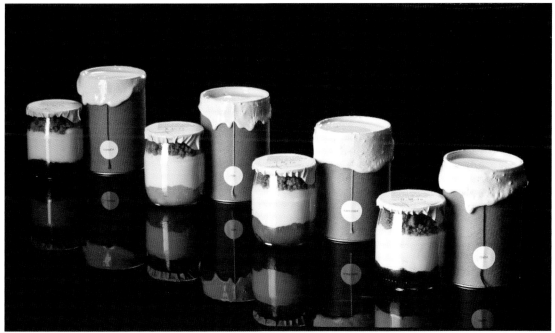

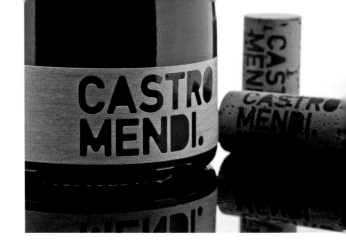

CastroMendi

client: Castro Mendi
studio: Javier Garduño Estudio de Diseño
Zamora, Spain
www.javiergarduno.com

CastroMendi is a young vineyard with a very strong relationship with innovative design, it's roots and nature, as the vineyard is situated in a small town in the La Culebra mountain range in Zamora. For this work we decided to make 3 different bottles for their wines, which do not have a cap but a characterising detail. The name is punched into the label, and as we drink the vine, the light passes through the name causing a spectacular effect. The labels are printed in natural kraft and paper free from chlorine, as well as the details of the necks, playing with the paper, natural raffia and grass string. Multi award-winning work in the design competitions in which they have been entered. BRONZE in LAUS 2014 in the packaging category. GOLD in PREMIOS INSPIRA 2014 in label design.

CastroMendi es una joven bodega con un compromiso muy fuerte con el diseño innovador, sus raíces y la naturaleza, ya que la bodega se encuentra situada en un pequeño pueblo en la sierra de La Culebra en Zamora. Para este trabajo decidimos hacer 3 botellas diferentes para sus vinos, que no llevaran cápsula si no un detalle que los caracterizara. El nombre en las etiquetas va troquelado, lo que hace que según vamos bebiendo el vino, la luz pasa por el nombre haciendo un efecto espectacular. Las etiquetas están impresas en kraft natural y papeles libres de cloro, al igual que los detalles de los cuellos, jugando con papel, rafia natural y cuerda de esparto. Trabajo multipremiado en los concursos de diseño que lo hemos presentado. LAUS de BRONCE 2014 en la categoría de packaging. ORO en diseño de etiqueta PREMIOS INSPIRA 2014.

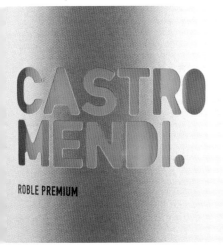

ROBLE PREMIUM

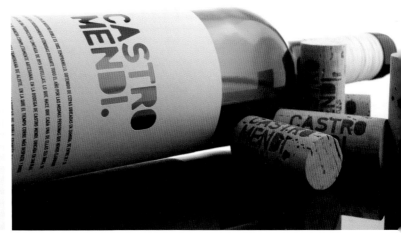

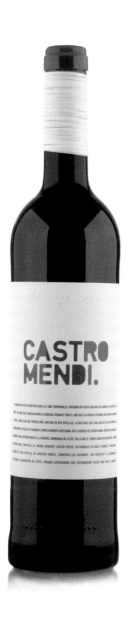
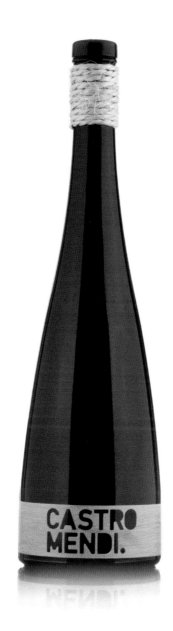
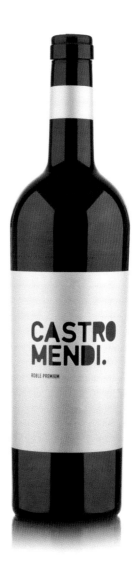

El Corral de Saus

client: El Corral de Saus
studio: Pepe Gimeno Proyecto Gráfico
designers: Pepe Gimeno, Baptiste Pons, Quique Casp
Godella, Valencia, Spain
www.pepegimeno.com

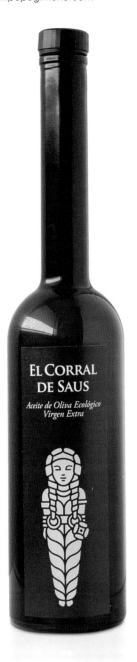
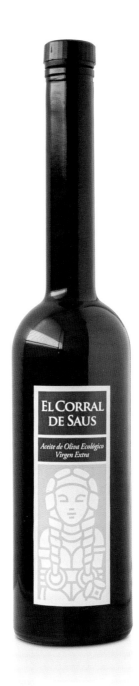
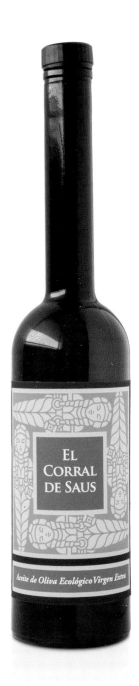

The project's aim was to design the graphic identity and label for a new ecological extra virgin olive oil. In the search for a name, it was considered to adopt the name of the Iberian necropolis "El corral de Saus" (VIII century), discovered in 1971 in the same lands where the olive groves are found. Once "El corral de Saus" was chosen as a name, the graphic image was designed to take into ac-count a characteristic which made reference to this necropolis. Between the pieces found, perhaps the most representative was an ensemble of four women who, forming a square and resting united by their right arm. We suggested working on this figure to convert it into the main motive of the image. The idea was to maintain the hieratic aspect and the disproportion of their arms and legs with respect to the head in order to conserve the archaic style. As a counterpoint, we use a clean and modern graphic to achieve a tender, youthful and fresh image.

El proyecto tenía como objetivo diseñar la identidad gráfica y la etiqueta para un nuevo aceite de oliva ecológico virgen extra. En la búsqueda de nombre, se barajó adoptar el nombre de la necrópolis ibérica "El corral de Saus" (siglos V-III a. C.), descubierta en 1971 en los mismos terrenos en que se encuentra el olivar.
Una vez elegido "El corral de Saus" como nombre, la imagen gráfica estaba abocada a tomar algún elemento que hiciera referencia a esa necrópolis. Entre las piezas encontradas, quizá la más representativa era un conjunto de cuatro damitas que, formando un cuadrado reposaban tumbadas unidas por su brazo derecho. Nos propusimos trabajar sobre esta figura para convertirla en el motivo principal de la imagen. La idea era mantener el aspecto hierático y la desproporción de sus brazos y piernas con respecto a la cabeza para que conservara su estilo arcaico. Como contrapunto, utilizamos una gráfica limpia y contemporánea para conseguir una imagen tierna, joven y fresca.

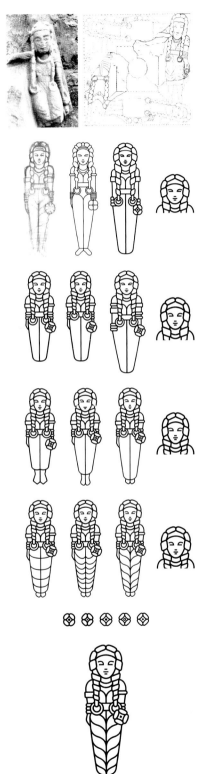

For the development of the design, the orography of the Planning zone is strategically taken as the story line, as it is a distinguishing feature, regarding other co-operatives, and gives their food and agriculture products characteristics which make them unique. The graphics and the packaging of the products they offer should show in an honest manner both its origin, a co-operative in the Alicante mountains, and it's manufacture method, using traditional growing techniques.

Two types of oil are presented: The cans are ecologically produced.

Para el desarrollo de la propuesta, se tomó estratégicamente como hilo argumental la orografía de la zona de Planes, puesto que es un punto diferenciador de ésta respecto a otras cooperativas y hace que sus productos agroalimentarios tengan unas características que los hacen únicos. La gráfica así como el packaging de los productos que ofrecen, debían exponer de manera honesta tanto su procedencia, una cooperativa de las montañas de Alicante, como su manera de hacer, la utilización de técnicas de cultivo tradicionales.

Se presentan dos tipos de aceite: El envasado en lata es de producción ecológica.

Cooperativa de Planes

client: Cooperativa de Planes
studio: Nueve Estudio
designer: Ana V. Francés, Cristina Toledo
Valencia, Spain
www.n-u-e-v-e.com

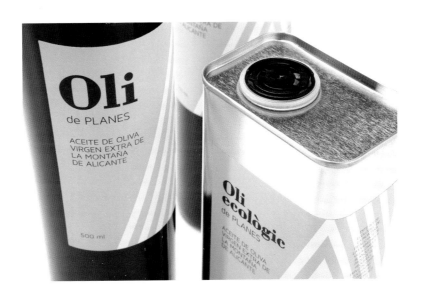

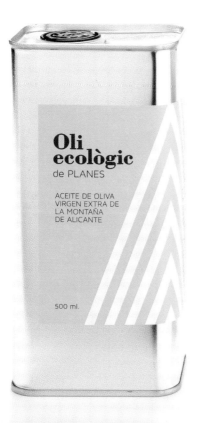

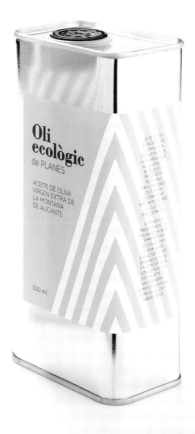

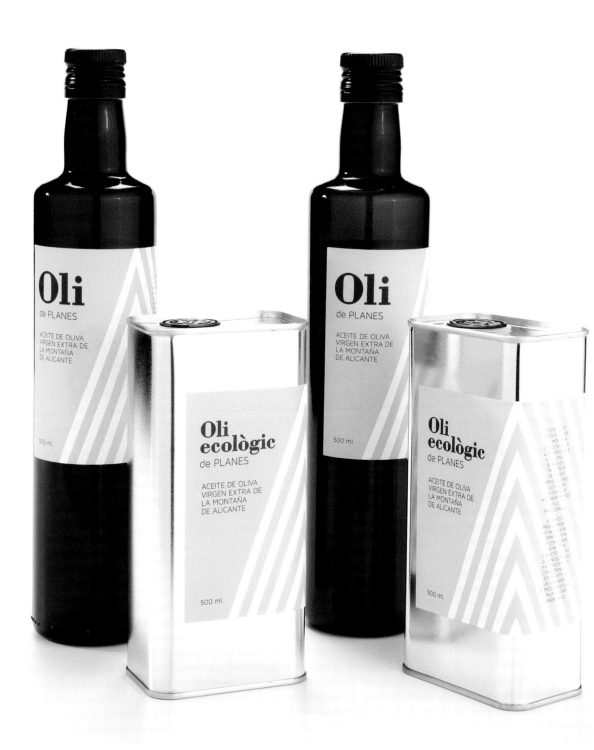

Abellaires Empordanesos

client: Abellaires Empordanesos
studio: Senyor Estudi
designers: Lluís Serra Pla, Mireia Sais Pelaez
Ventalló, Spain
www.senyorestudi.com

Beyond aerial acrobatic aesthetics, the dance of the bees is a precise communication system which allows them to calculate distances and locations. The flight characteristic –in boundless form– coverts into a monogram with the initials of Abellaires Empordanesos (AE). Moving the same language to packaging, watermarks and dotted lines recall the coming and going of the flight of bees.

The brand has three product lines: 1. Basic line: the most constant honeys (thousand flower honey, orange tree, helm-rosemary-thyme, chestnut, mountain honey and a selection from Alberes). 2. Small harvest line: limited editions, small production and very irregular: lemon tree, heather, springtime heather, eucalyptus... these vary with each harvest. 3. Ecological line: this is very interesting, as apart from being ecological, the beehives are situated in Natural Parks and Parks of Natural interest. The original briefing was a redesign and improvement of the product range. They still had the same labels as fifty years ago. For us, as designers, it was very interesting, but they needed a face wash to transmit a youthful and fresh image and therefore adapt themselves to new markets. It was very important for the client to maintain the same colour code in the basic line, so as not to confuse consumers, but the ecological line and the small harvest also had to be incorporated. A radical change was made in the choice of paper: they went from a glossy paper to another offset recycled one, giving a much more natural touch to the product.

Más allá de estéticas acrobacias aéreas, la danza de las abejas es un preciso sistema de comunicación que les permite calcular distancias y localizaciones. El característico vuelo –en forma de infinito– se convierte en un monograma con las iniciales de Abellaires Empordanesos (ae). Trasladando el mismo lenguaje al packaging, filigranas y líneas de puntos recuerdan el ir y venir del vuelo de las abejas.

La marca tiene tres líneas de producto: 1. Línea básica: las mieles más constantes (miel de milflores, naranjo, timón-tomillo-romero, castaño, miel de montaña y selección de las Alberes). 2. Línea de pequeña recolección: ediciones limitadas, de poca producción y muy irregulares: limonero, brezo, brezo de primavera, eucalipto... estas varían en cada recolección. 3. Línea ecológica: esta es muy interesante, ya que aparte de ser ecológica, las colmenas están situadas en Parques Naturales y Parajes de interés Nacional.

El *breefing* original era un rediseño y ampliación de la gama de producto. Todavía tenían las mismas etiquetas que cincuenta años atrás. A nosotros, como diseñadores, nos parecían muy interesantes, pero necesitaban un lavado de cara para transmitir una imagen joven y fresca y así adaptarse a los nuevos mercados. Era muy importante para el cliente mantener el mismo código de color en la línea básica, para no desorientar a los consumidores, pero también se tenía que incorporar la línea ecológica y la de pequeña recolección. Se hizo un cambio radical en la elección del papel: se pasó de un papel satinado a otro *offset* reciclado, aportando un tacto mucho más natural al producto.

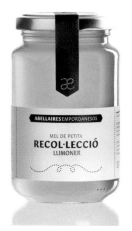
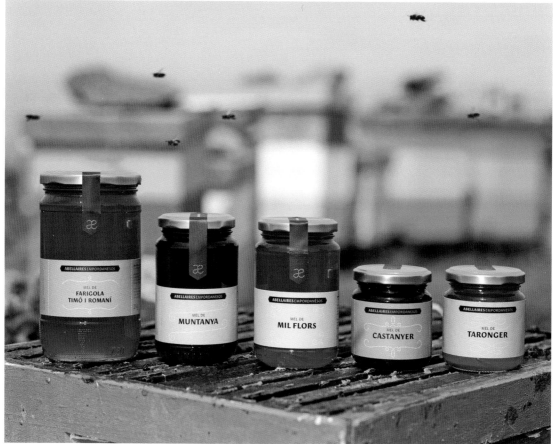

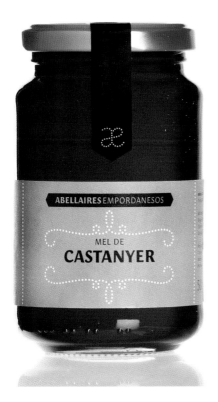

MEL DE
CASTANYER

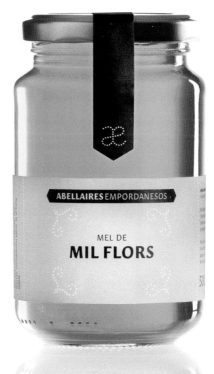

MEL DE
MIL FLORS

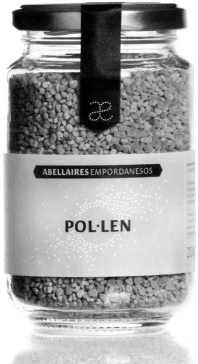

POL·LEN

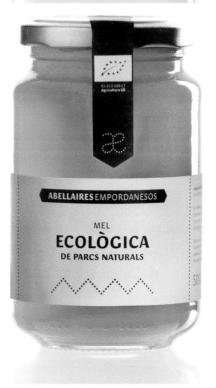

MEL
ECOLÒGICA
DE PARCS NATURALS

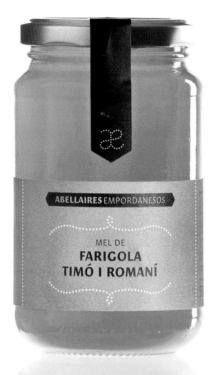

ABELLAIRES EMPORDANESOS

MEL DE
FARIGOLA
TIMÓ I ROMANÍ

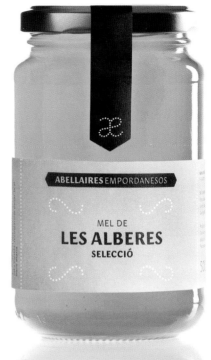

ABELLAIRES EMPORDANESOS

MEL DE
LES ALBERES
SELECCIÓ

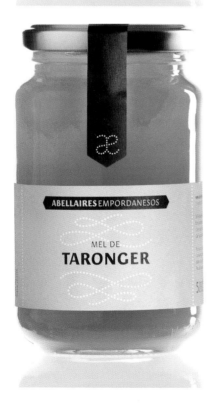

ABELLAIRES EMPORDANESOS

MEL DE
TARONGER

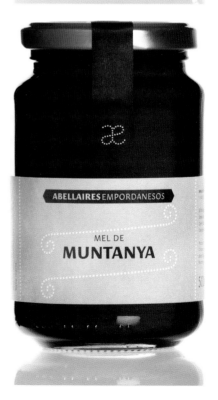

ABELLAIRES EMPORDANESOS

MEL DE
MUNTANYA

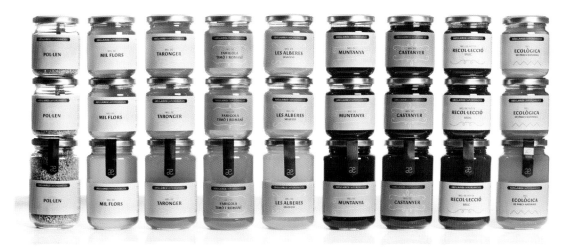

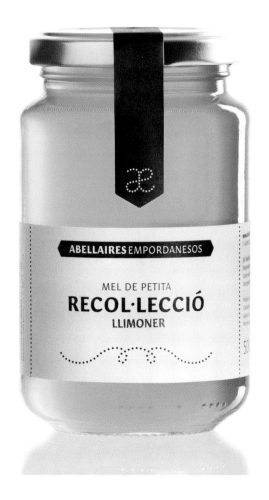

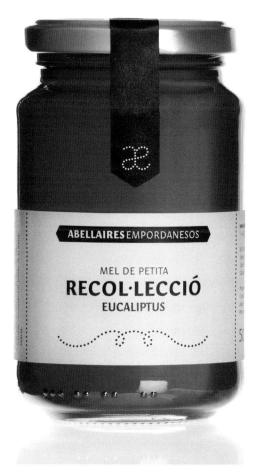

Mel Ecològica

client: Ous Empordà
studio: Senyor Estudi
designers: Lluís Serra Pla, Mireia Sais Pelaez
Ventalló, Spain
www.senyorestudi.com

Between the mountains of the Salines-Bassegoda Natural Park of National Interest, and within walking distance of the Muga river, you can find an ecological farm known as Mas Rimbau of Dalt, situated in Sant Llorenc de la Muga (Girona). Chickens, bees and ecological garden live together in harmony in this idyllic spot, and the resulting products are sold in a little improvised shop in the old straw loft of the farm. Based on the economy inks and the standardisation of labels –which are completed manually with variable information– a unique label is adapted to the different forms of packaging.

Entre las montañas del Paraje Natural de Interés Nacional Salines-Bassegoda, y a pie del río Muga, se encuentra una finca ecológica conocida como Mas Rimbau de Dalt, situada en Sant Llorenç de la Muga (Girona). Gallinas, abejas y huerta ecológica conviven en harmonía en este paraje idílico, y los productos resultantes se venden en una tiendecita improvisada en el antiguo pajar de la masía. Partiendo de la economía de tintas y la estandarización en las etiquetas –que son completadas manualmente con la información variable– una etiqueta única se adapta a los diferentes formatos de los envases.

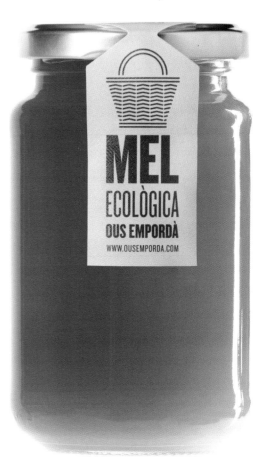

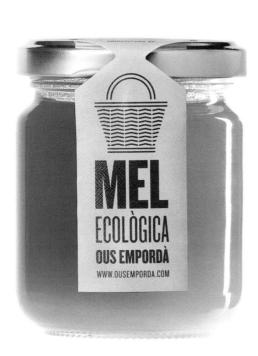

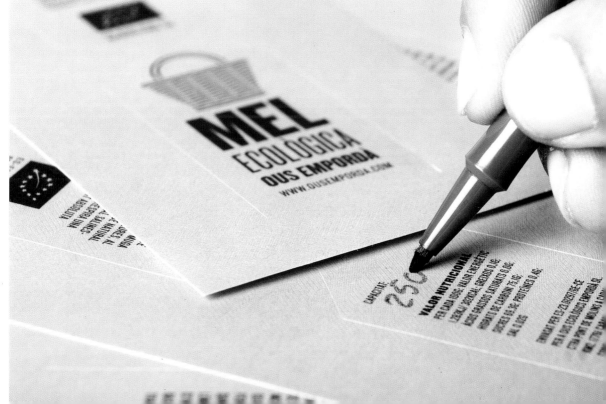

Oju! Vinagre de vino

client: Celler La Vinyeta
studio: Senyor Estudi
designers: Lluís Serra Pla, Mireia Sais Pelaez
photos: Marc Roca, Xavier Iborra
Ventalló, Spain
www.senyorestudi.com

The history of this vinegar goes back many years. The mothers of these vinegars came from two barrels of more than 80 years recuperated in an old vinegar factory. After years of splendour, the juncture and loss of the go-ahead spirit had condemned the factory to an unstoppable decline. It had been a prosperous industry and now it had shattered in moments. The dust and cobwebs seized a space which had shone it times gone by. That which was for many a ruin and scrap, for us housed a great treasure: the mother of vinegar.

Each barrel produced a vinegar of different smell, colour and taste, creating a symphony when they are together. Their bright colours, which range from straw yellow to brick red passing through different tones of amber could trick us: it is not a sweet wine, it is not an oxidised wine. A warning came to us: Alert! Wine vinegar.

Elaborating on the original method, the natural treatment of this domestic production received minimum filtration to maintain all the properties, which could contain natural sediments coming from their own mothers. It is these sediments which are the driving force of making up the properties of the vinegar and conditioning it's qualities. There are no two equal iris, just like there are no two equal vinegars. Printing the characteristics onto the cork tops forms the label. An eye which changes colour. A letter O. Oju! (Alert!) A symphonic harmony.

La historia de este vinagre se remonta a años atrás. Las madres de estos vinagres provienen de dos botas de más de 80 años recuperadas en una antigua vinagrería. Después de años de esplendor, la coyuntura y la pérdida del espíritu emprendedor habían condenado aquella factoría a un declive imparable. Había sido una industria próspera y ahora se hacía añicos por momentos. El polvo y las telarañas se apoderaban de un espacio que había lucido en tiempos pretéritos. Aquello que para muchos era ruina y chatarra, para nosotros guardaba un gran tesoro: la madre del vinagre.

Cada bota produce un vinagre de olor, color y sabor diferente, creando una sinfonía cuando están juntos. Sus colores vivos, que van del amarillo paja al rojo teja pasando por diferentes tonalidades de ámbar nos podrían engañar: no es un vino dulce, no es un vino de oxidación. Una advertencia nos alerta: Oju! Vinagre de vino.

Elaborado con el método tradicional, el tratamiento natural de esta producción doméstica de vinagre recibe el filtraje mínimo para mantener todas las propiedades, por lo que puede contener pósitos naturales provenientes de las propias madres. Son estos posos los encargados de otorgar las propiedades al vinagre y condicionar sus cualidades.

No hay dos iris iguales, de la misma forma que no hay dos vinagres iguales. Estampaciones con los característicos tapones de corcho dan forma a la etiqueta. Un ojo que cambia de color. Una letra O. Oju! Una harmonía sinfónica.

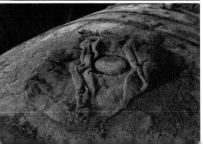

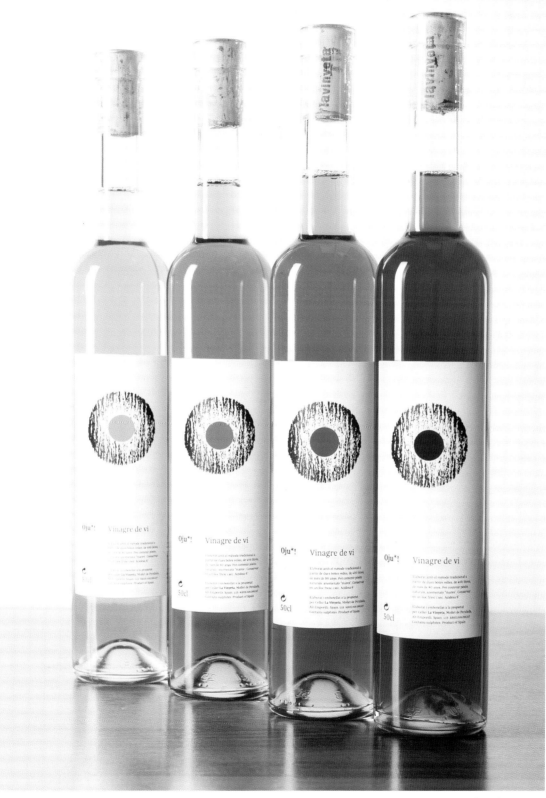

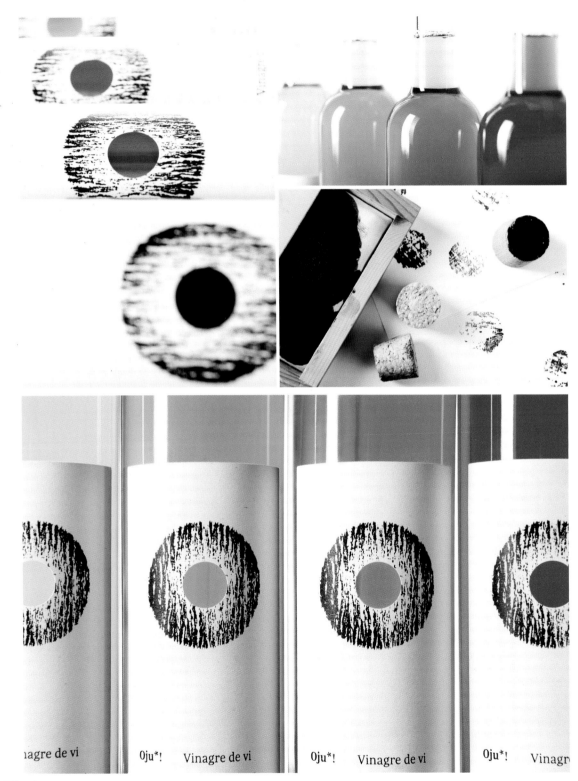

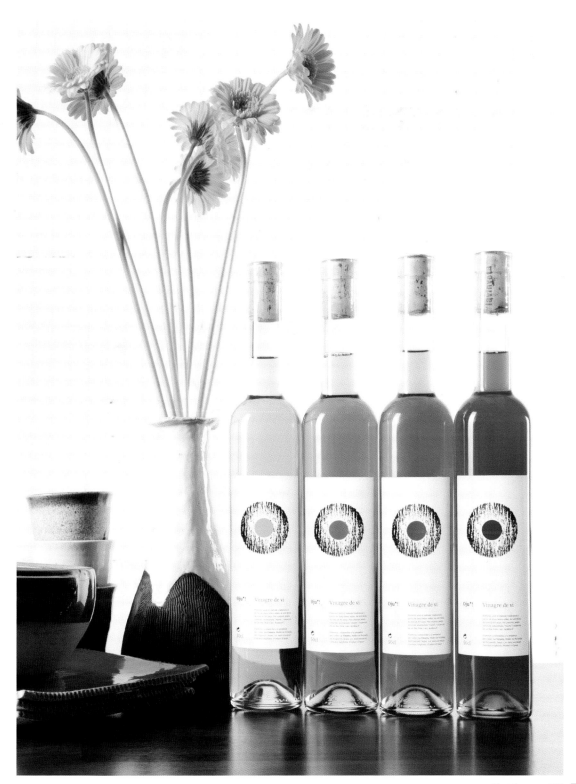

Olive Oil

client: Olivar
designer: Alexander Pogrebniak
Krakow, Poland
www.behance.net/alexpogr

Olive oil is a great natural product which has a delightful flavor and beneficial qualities. These qualities were central in creating packaging design called Olivar. Emphasis was placed on minimalism, simplicity of forms and colors. The series includes several types of olive oil with various natural additives (Classic, Chilli, Rosemary). The design of each type is made in its own color, which is associated with the corresponding aromatic spice added to the oil.

El aceite de oliva es un producto natural fantástico que tiene un sabor delicioso y unas cualidades beneficiosas, las cuales fueron esenciales a la hora de crear el diseño del envase llamado Olivar. Se puso énfasis en el minimalismo y en la simplicidad de las formas y los colores. La serie incluye varios tipos de aceites de oliva con diversos aditivos naturales (clásico, con chile, con romero). El diseño de cada uno se ha hecho con su propio color, el cual está asociado con la correspondiente especia aromática añadida al aceite.

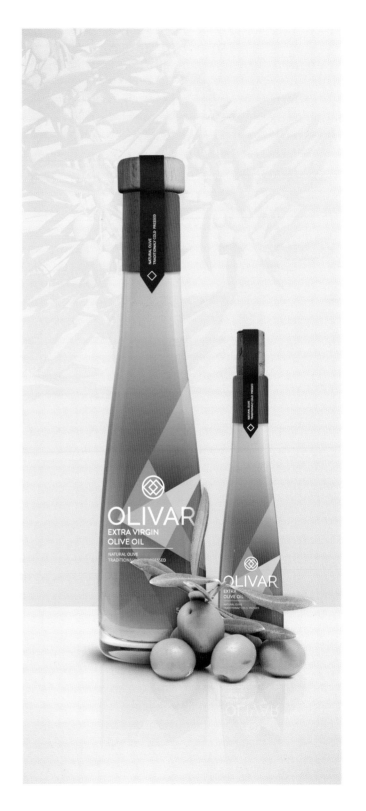

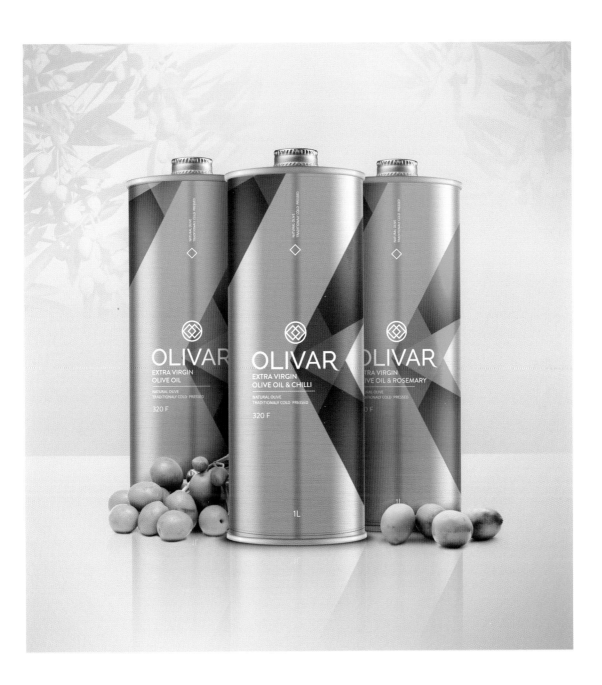

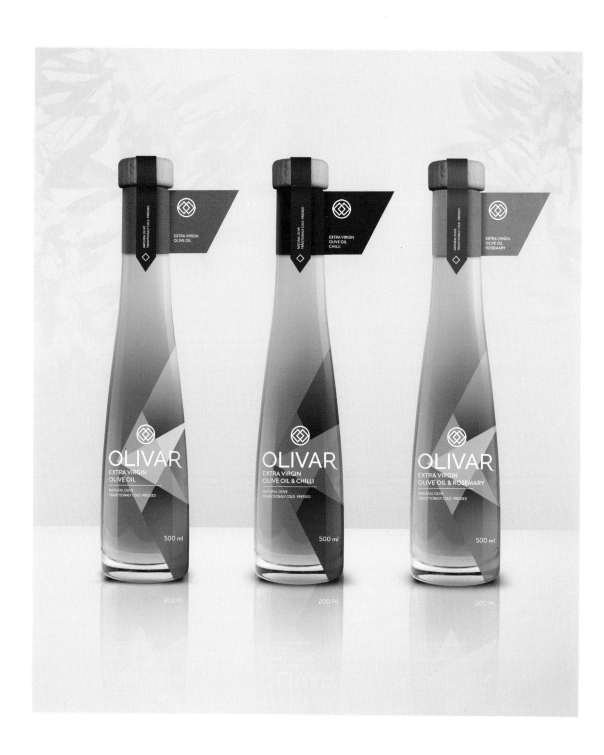

Lepanto – the actual white

client: Lepanto Dairies
studio: Sophia Georgopoulou | Design
Athens, Greece
www.www.sophiag.com

The client's brief was to create a brand identity & packaging for the start up Lepanto Dairies, specializing in Greek traditional dairy goods. The target audience is mainly young urban professionals keen to a healthy lifestyle and who value authenticity and traditions.

Feta, the pure, the authentic white cheese made the traditional way, full of health benefits. Comes in cubes, inside a glass jar to make it easy for consumption which makes it a friendly product to new triers. Feta Lepanto is the new trend of healthy lifestyle, a premium delicacy for those who are willing and able to appreciate quality and fine goods.

A combination of the old and the new, of traditional and new trends. The premium, the authentic, the actual white.

El encargo del cliente era crear la identidad corporativa y los envases para la nueva empresa Lepanto, especializada en productos lácteos griegos tradicionales. El público objetivo es principalmente profesionales jóvenes y urbanos aficionados a un estilo de vida saludable y que valoran la autenticidad y las tradiciones.

El queso feta, el auténtico y puro queso blanco hecho de forma tradicional, está lleno de beneficios saludables. En forma de cubos, viene dentro de un tarro de vidrio para que su consumo sea más fácil, lo cual lo convierte en un producto agradable para aquellos que lo prueban por primera vez. El queso feta de Lepanto es la nueva tendencia para un estilo de vida saludable, un manjar exquisito para aquellos que quieren y pueden apreciar productos excelentes y de calidad.

Combina lo viejo y lo nuevo, lo tradicional y lo moderno. El blanco de calidad superior, el auténtico.

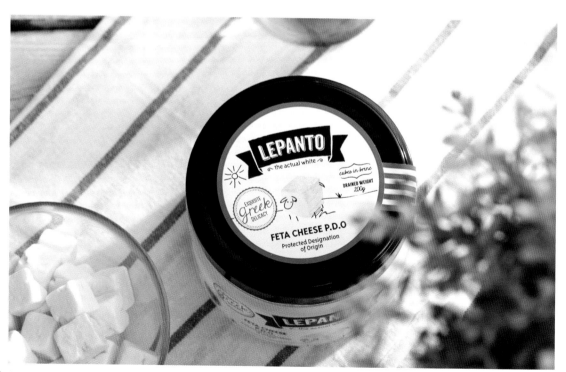

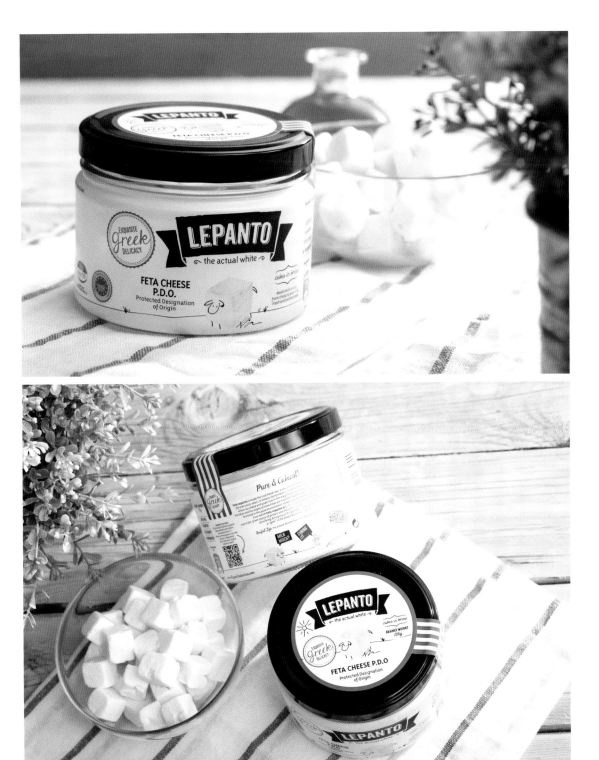

Olive Forever

client: Olive Forever
studio: Sophia Georgopoulou | Design
Athens, Greece
www.www.sophiag.com

The client's brief was to create a brand identity for Damala family's Extra Virgin Olive Oil.

The olive oil is being produced for years within the family, out of fruits selected from their own olive groves in Argolida, Peloponnese, Greece.

Olive Forever is a fresh arrival which seals traditional production methods, organic culture and the ethics of a three-generations olive cultivation, in a bottle. This new product takes a turn, and starts its long journey abroad to say hello to a world-wide audience, and to spread the benefits of the olive tree wisely. Olive Forever revolves around the very essence of human existence and its mission is to satisfy the need to live a long and healthy life.

In the Mediterranean basin, Greece in particular, olive oil is considered to be sacred, hence the local diet is based on it both for its health benefits and for its delicious flavour.

Olive Forever represents the preciousness of olive oil.

The golden juice known -since the ancient times- to nurture, to heal and to create longevity. Life's precious essence.

El encargo del cliente era crear la identidad de marca para el aceite de oliva virgen extra de la familia Damala.

Esta familia lleva años produciendo aceite de oliva a partir de los frutos seleccionados de sus propias arboledas de olivos en Argólida, el Peloponeso, Grecia.

Olive Forever es una novedad que encierra los métodos de producción tradicional, la cultura orgánica y la ética del cultivo de oliva de tres generaciones en una botella. Ahora es el turno de este nuevo producto que empieza un largo viaje por el extranjero para presentarse a un público internacional y para propagar sabiamente los beneficios de la oliva. Olive Forever gira en torno a la propia esencia de la existencia humana y su misión es satisfacer la necesidad de vivir una vida larga y saludable.

En la cuenca del Mediterráneo, en particular en Grecia, el aceite de oliva se considera algo sagrado, de ahí que sea la base de la dieta de la región tanto por sus beneficios en la salud como por su delicioso sabor.

Olive Forever representa lo valioso que es el aceite de oliva. Zumo dorado, conocido así desde tiempos inmemorables, para nutrir, curar y generar longevidad. La preciada esencia de la vida.

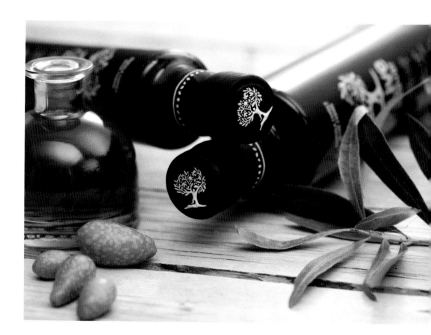

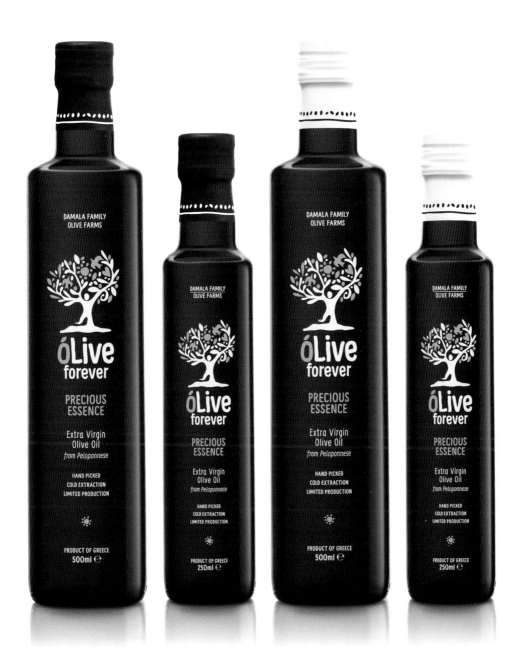

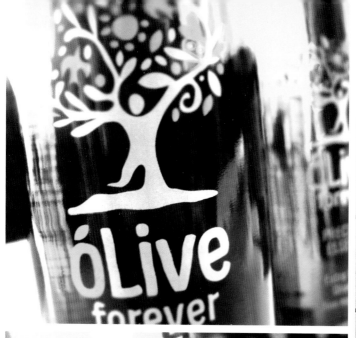

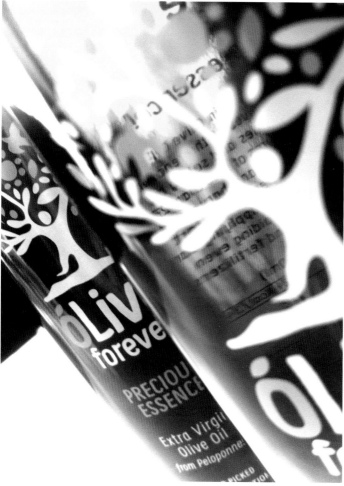

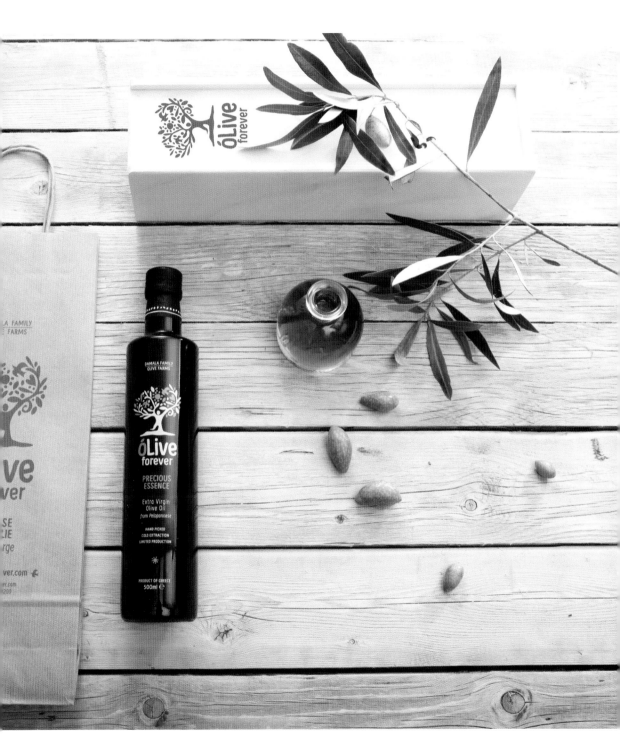

Home by Nature

client: Home by Nature Co.
studio: Sophia Georgopoulou | Design
Athens, Greece
www.www.sophiag.com

Taking into consideration the brand name "HOME", the company's name "HOME by nature" as well as the brand philosophy, a hand crafted logo was created that symbolizes the path leading to home. The logo's outline projects an olive oil drop which is the symbol of nurturing and purity since the product is an extra virgin olive oil which contains some of the basic ingredients of any health boosting diet.

The packaging following the concept, keeps the aesthetics of clean lines projecting the purity of the product. The Home Supreme bottle is cubical reflecting the outline of a traditional greek house. Therefore, opening the bottle, one shares his home with the ones close to his heart.

The color palette is inspired by the actual olive leaves, the olive fields and in general the greek landscape, bringing out the notion of a country-side homeland.

The fonts were "treated" in a way to enhance the feeling of handmade good since the "Home by Nature" entire business is a family business with a long tradition in olive oil production.

Teniendo en cuenta el nombre comercial HOME, el nombre de la empresa HOME by Nature y la filosofía de la marca, se diseñó a mano un logotipo que simbolizase el camino que te lleva a casa. El boceto del logotipo refleja una gota de aceite de oliva, que es el símbolo de la nutrición y la pureza, ya que el producto es un aceite de oliva virgen extra que contiene algunos de los ingredientes básicos de cualquier dieta saludable.

El envase sigue este concepto y mantiene la estética de unas líneas limpias que reflejan la pureza del producto. La botella Home Supreme tiene forma cúbica y recuerda la estructura de una casa griega tradicional. Por lo tanto, cuando uno abre la botella, comparte su casa con aquellos a los que más quiere.

La paleta cromática se inspira en las hojas del olivo, los campos de dicho árbol y, en general, en el paisaje griego. Todo ello intensifica la idea de una tierra campestre.

Las fuentes se «trataron» para que la sensación de que es un producto hecho a mano fuese mayor, ya que Home by Nature es un negocio familiar con una larga tradición en la producción de aceite de oliva.

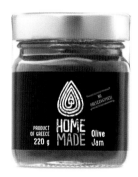

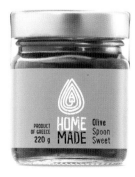

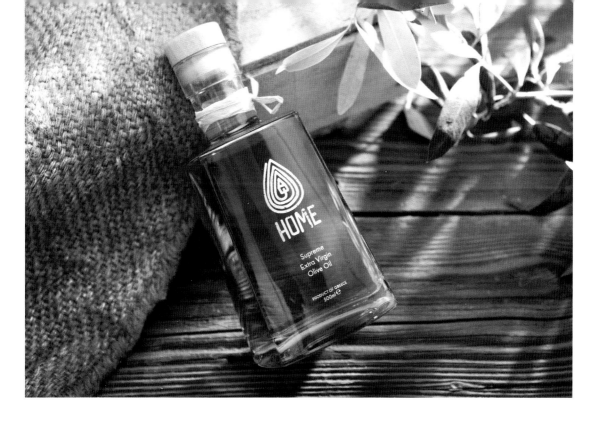

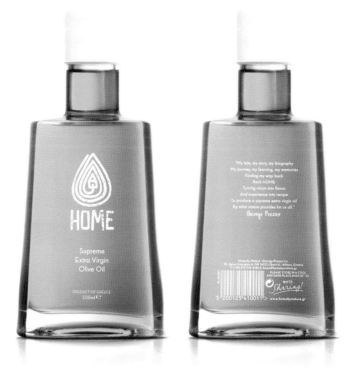

Ecoproductes de Gallecs

client: Associació agroecològica de Gallecs
studio: Can Cun
photographer: Anna Rigau
Granollers (Barcelona), Spain
www.fromcancun.com

Ecologically produced products.
Eco-design for products of the Gallec Agro-Ecological Association. Product of proximity and Km 0.
They wanted a product that would reduce environmental impact and cost. We have created a line of products which are mostly free of glue to facilitate the separation of waste. To attach the label we have chosen an elastic band, which can be reused various times before being recycled.
We also emphasise playing with proverbs and popular sayings which refer to the enclosed products. The majority of the paper is recycled, free from chlorine, and follows environmental criteria, using only one dye and incorporating different recipes on the back of the label, so as to be able to reuse it before recycling it. Received the bronze Laus prize in 2012.

Productos de producción ecológica.
Ecodiseño para los productos de la Asociación agroecológica de Gallecs. Producto de proximidad y Km 0.
Querían un producto que redujera el impacto ambiental y su coste. Hemos creado una línea de productos que en su mayoría son libres de pegamento para facilitar la separación de residuos. Para poder unir la etiqueta hemos escogido la goma de caucho, ya que se puede reutilizar varias veces antes de reciclarla.
Destacamos también el juego de los refranes y dichos populares referentes a los productos envasados. Los papeles, en su mayoría, son reciclados, libres de cloro, y siguen criterios ambientales, utilizando una sola tinta e incorporando diferentes recetas al dorso de la etiqueta, para poder reutilizarlo antes de reciclarlo. Recibió el premio Laus 2012 de bronce.

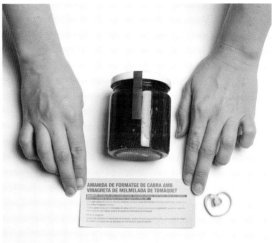
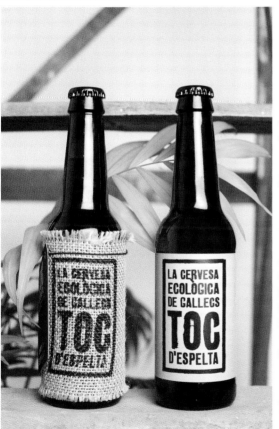
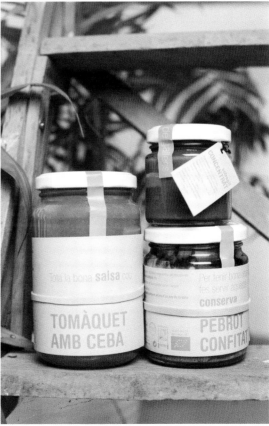

Mondariz

client: Aguas de Mondariz
Mondariz, Spain
www.aguasdemondariz.com

With the aim of adhering to international market standards, Aguas de Mondariz, which is distributed in 29 countries, has opted for two new glass formats: the 750-ml bottle for table service and a 330-ml for individual consumption. Furthermore, transparent glass bottles were chosen for spring water, while emerald-green was used for mineral water, a change which has brought back the traditional bottle demarcation for these products and into line with international color coding for carbonated water.

Con el objetivo de adaptarse a los estándares del mercado internacional, Aguas de Mondariz, que tiene distribución en 29 países, apuesta por dos nuevos formatos de vidrio: la botella de 750 ml para el consumo en mesa y la de de 330 ml para el consumo individual. Además, opta por el vidrio transparente para las botellas de agua sin gas y el color verde esmeralda para las de agua con gas, un cambio que recupera la antigua diferenciación de botellas por productos y se alinea con los códigos cromáticos internacionales del agua carbonatada.

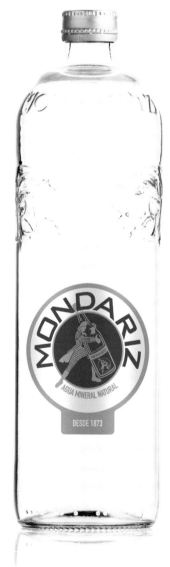
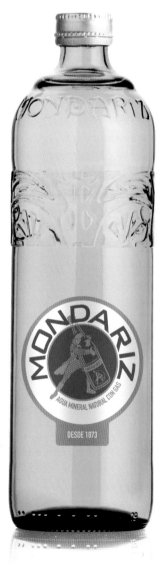

Lauretana

client: Lauretana
Graglia, Italy
www.lauretana.com

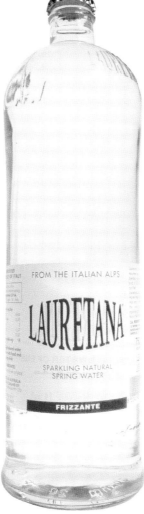

The sinuous design of the Lauretana bottle designed by Pininfarina, with a cylindrical formal development, the most natural "dress" for water.

El sinuoso diseño de la botella de Lauretana fue creado por Pininfarina, con un desarrollo formal cilíndrico, el "vestido" más natural para el agua.

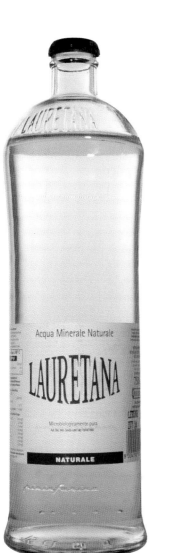

Ty Nant

client: Ty Nant
Bethania, Wales, United Kingdom
www.tynant.com

Perhaps the most revolutionary aspect of Ty Nant is the company's innovative break with the old Victorian convention of using blue bottles to contain poison, and instead presenting blue as a pure and refreshing, wholly drinkable colour. Ty Nant courageously established this precedent in 1989, when it first presented the unique bottle to the world at the London Savoy, to much acclaim and subsequent design awards.

To celebrate ten years of bringing unrivalled style to the tables of customers around the world, Ty Nant launched 'Ty Nant Too' in 1999 - an equally audacious crimson bottle. In keeping with the already famous blue bottle, reminiscent of blue glass traditionally made in Bristol in the 1800's, the crimson colour is also associated with the renowned glass-houses of Bristol.

Tal vez el aspecto más revolucionario de Ty Nant sea el atrevimiento de la empresa a romper con la antigua costumbre victoriana de usar botellas azules para contener veneno, y en lugar de ello presentar el color azul como algo puro y refrescante, un color completamente potable. Ty Nant estableció con coraje este precedente en 1989, cuando presentó por primera vez la exclusiva botella al mundo en el Savoy Londres, siendo aclamada y subsiguientemente premiada.

Para celebrar sus diez años aportando un estilo inigualable a las mesas de los clientes de todo el mundo, Ty Nant lanzó "Ty Nant Too" en 1999, una botella de color carmesí igualmente atrevida. Al igual que la ya famosa botella azul, reminiscencia del vidrio azul tradicionalmente fabricado en Bristol en 1800, el color carmesí también se asocia con las famosas vidrierías de Bristol.

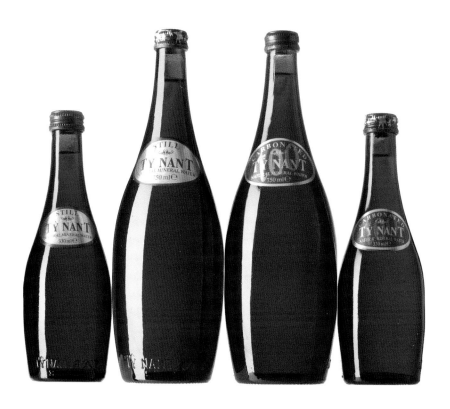

Waiwera

client: Waiwera water
Auckland, New Zealand
www.waiwerawater.co.nz

This bottle is based on the original bottle from 1875, look closely and you will see that it is completely free-form, flowing naturally, it is non-concentric and subtly different from every angle giving the impression that it was hand-blown using traditional techniques.
Famous for centuries for the therapeutic and curative properties of its natural geothermal artesian water, Waiwera (in full Waiwerawera) literally translates as "extremely hot water" due to the fact that it rises naturally to the surface at 53°C (127°F). Waiwera Artesian Water is recognised as the " world's Best Water" and the brand will become a 'kiwi icon', celebrated around the world for the quality of its product, packaging and customer service. Pronounced 'why-wear-ah', meaning 'hot water'.

Basada en la botella original de 1875, observándola de cerca se aprecia que está completamente libre de forma, que fluye naturalmente, que no es concéntrica y que es sutilmente diferente desde cada ángulo, dando la impresión de que se sopló a mano, usando técnicas tradicionales.
Waiwera (su nombre completo es Waiwe-rawera) ha sido famosa durante siglos debido a las propiedades terapéuticas y curativas de su agua artesiana natural geotérmica. Su nombre se traduce literalmente como "agua extremadamente caliente" debido al hecho de que surge en la superficie de forma natural a 53°C. El Agua Artesiana Waiwera es reconocida como "la mejor agua del mundo" y la marca se convertirá en un icono kiwi. Es alabada en todo el mundo por la calidad de su producto, su packaging y su servicio al cliente.

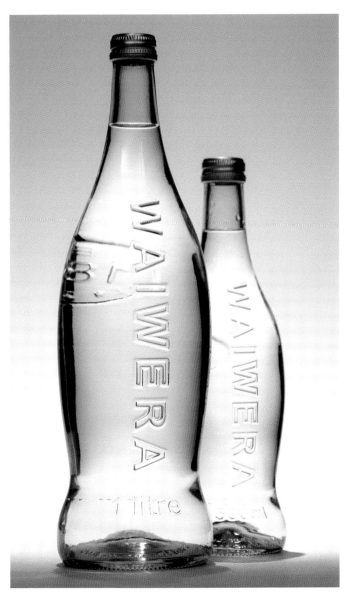

Finé

client: Finé
Tokyo, Japan
www.finejapon.com

Both still and sparkling Finé water comes available in frosted glass bottles. All bottles are recyclable and have a special coating that protects Finé from damaging Ultra-violet light. And all glass is produced to Finé's exact specifications by Japan's oldest and most renowned glassmaker, Nihon-Yamamura Glass, so it was a natural choice for Finé to ask for their assistance in the design and manufacturing process. After an exhaustive 2-year period of collaboration, the final Finé designs were completed and it was time to begin bottling. Throughout this process, all bottles are checked by hand for any imperfections or scratches in the finish. Any bottles found to be below standards are sent away to be recycled and molded again before returning to Finé facilities.

Tanto el agua Finé con gas como sin gas están disponibles en botellas de vidrio glaseado. Todas las botellas son reciclables y están dotadas de una capa especial que protege a Finé del daño provocado por la luz ultravioleta. Además, todo el vidrio cumple con las especificaciones exactas que Finé proporciona a la vidriería más antigua y reputada de Japón, Nihon-Yamamura Glass, con la que cuenta para que le proporcione su ayuda en el proceso de diseño y fabricación. Tras dos años exhaustivos de colaboración, se completaron los diseños finales de Finé y llegó el momento de empezar a embotellar. Durante este proceso, todas las botellas se comprueban a mano buscando cualquier posible imperfección o rasguño en el resultado final. Cualquier botella que no cumpla con los estándares es enviada para ser reciclada y moldeada de nuevo antes de volver a las instalaciones de Finé.

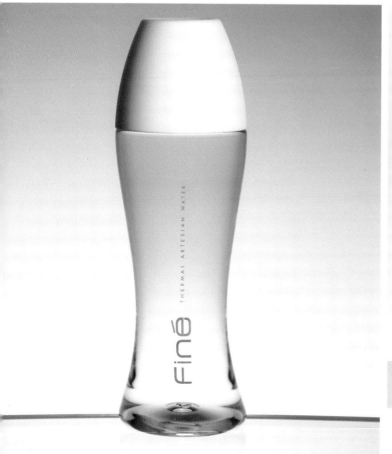

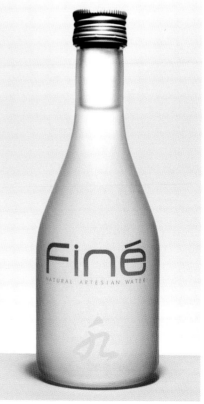

Aquadeco

client: Aquadeco
New York, USA
www.aquadecowater.com

Arnold Gumowitz, founder of Aquadeco Premium Spring Water combined this pure Canadian spring water with his Art Deco-inspired water bottle. His design, derived from his love for real estate and art, embodies a statuesque Art Deco structure. To bring the bottle to life, he teamed with Flowdesign, a Manhattan firm that provides innovative design solutions from beverages to household goods.

Arnold Gumowitz, fundador de Aquadeco Premium Spring Water combinó esta agua pura de manantial canadiense con su botella inspirada en el Art Decó. Su diseño, procedente de su amor por la arquitectura y el arte, representa una estructura escultural Art Decó. Para crear esta botella se unió a Flowdesign, una firma de Manhattan que crea diseños innovadores para todo tipo de bienes, desde bebidas hasta enseres domésticos.

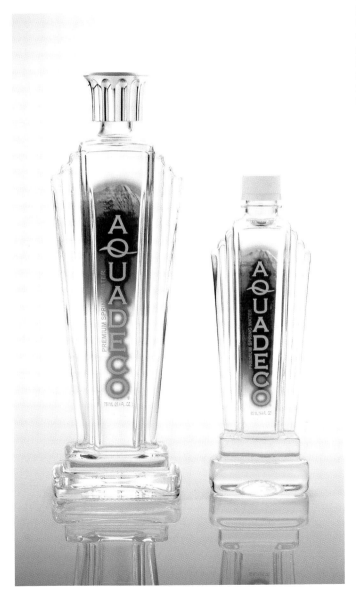

Chapter 3

BAGS

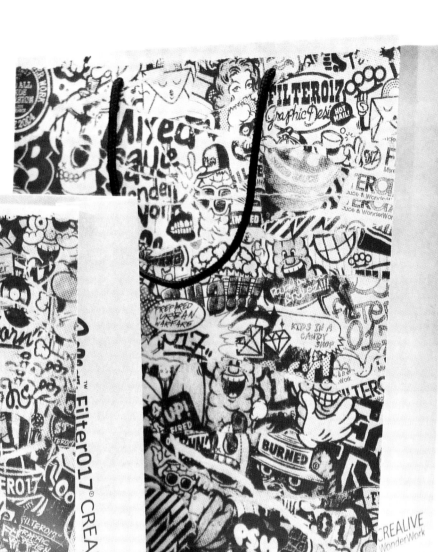

Zen Winebag

client: Ciclus
studio: Ciclus
designer: Tati Guimarães
Barcelona, Spain
www.ciclus.com

The bag-packaging for wine is part of the
collection Zen Collection.
The word Zen is the Japanese pronunciation
of the Chinese word Chan which also derives
from the Sanskrit word Dhiana which means
"meditation". Zen Collection searches for
the experience of wisdom beyond rational
speech. It is a collection of simple and
functional products which breathe elegance
and originality through durable and innovative
material: 100% recycled leather.
The material used is 100% recycled leather
(single material) - the packaging comes from
a singular label. It does not use glue or sewing,
only laces for it's assembly. It is made with a
minimum amount of materials and processes.
The packaging is designed for 1 wine or 2
wines. It is delivered flat to facilitate and
minimise trans-portation, as well as delivery. It is
also assembled quickly to facilitate use.

El packaging-bolsa para vinos es parte de la
colección Zen Collection.
La palabra Zen es la pronunciación en
japonés de la palabra china *Chan* que a su
vez deriva de la palabra sánscrita *Dhiana*,
que significa "meditación". Zen Collection
busca la experiencia de la sabiduría más allá
del discurso racional. Es una colección de
productos simples y funcionales que respiran
elegancia y originalidad a través de un
material durable e innovador: el cuero100%
reciclado.
El material utilizado es piel 100% reciclada
(monomaterial) - el packaging sale de un solo
troquel. No lleva pegamento o
costura, solo encajes para su montaje.
Está hecho con el mínimo de materiales y
procesos.
El packaging esta diseñado para 1 vino o
2 vinos. Se entrega en plano para facilitar
y minimizar el transporte, así como su
almacenaje. También es de rápido montaje
para facilitar el manipulado.

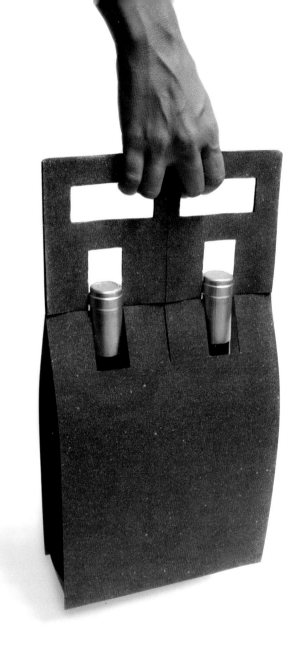

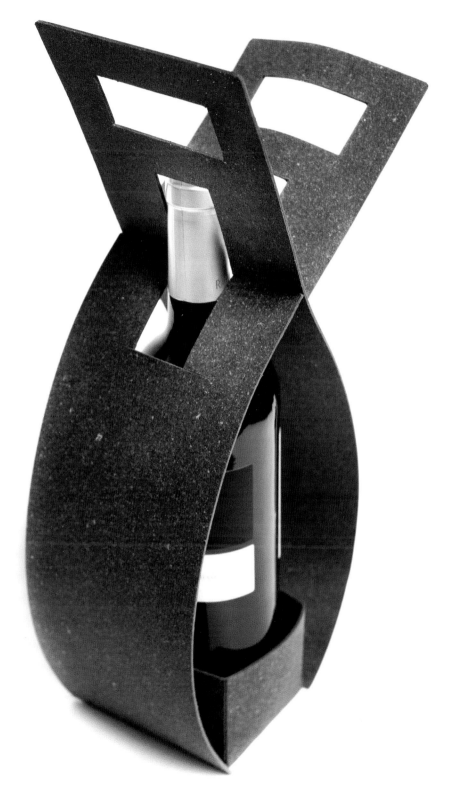

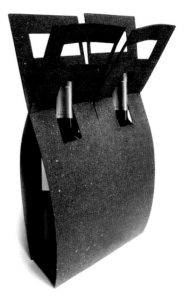

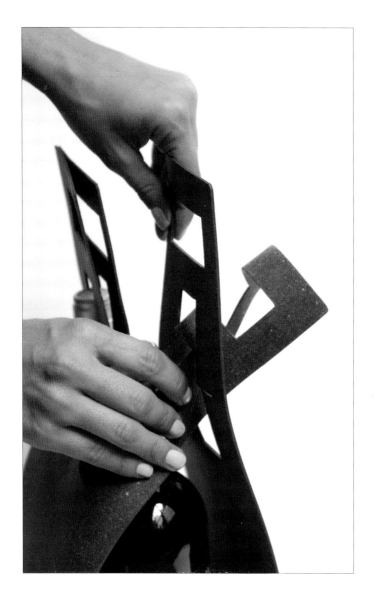

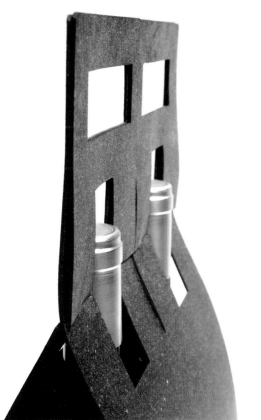

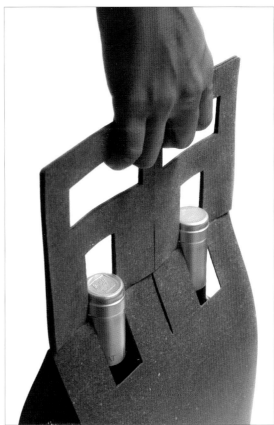

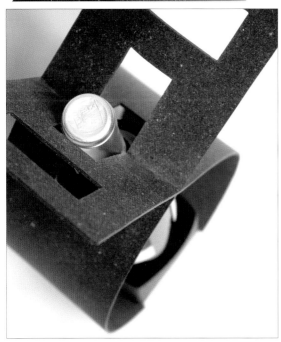

Tote Bags for Kordon Blu

client: Self Promotion
studio: Tena Letica
designer: Tena Letica
illustrator: Tena Letica
www.behance.net/tenaletica

These 100% cotton bags are silk screen printed. The limited edition bags feature black polypropylen handle. The bags measure 39 x 40 cm in size. These canvas bags are a great alternative to plastic shopping bags. They are especially convenient for grocery shopping and running errands. Unlike plastic bags, these bags are ecologically friendly, durable and washable. Each bag illustration features an animal with their specific characteristic, for example a skunk's poor eyesight.

Estas bolsas de 100% algodón están serigrafiadas. Las bolsas de edición limitada tienen unas asas de polipropileno negro y miden 39 x 40 cm. Estas bolsas de lona son una estupenda alternativa a las bolsas de plástico. Además, son muy prácticas a la hora de ir a comprar alimentos o hacer un recado. A diferencia de las bolsas de plástico, estas son ecológicas, duraderas y lavables. En cada ilustración sale un animal con su característica específica, como por ejemplo una mofeta y su mala vista.

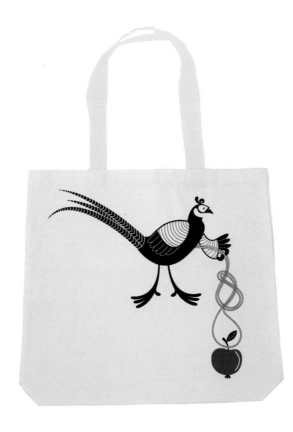

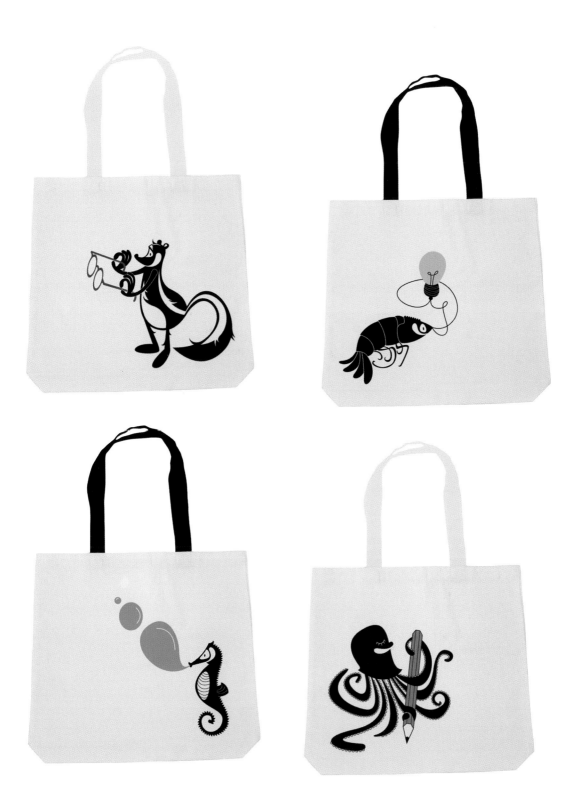

Due to the consumer behavior in Thailand, people often give whiskey as present for special occasion. With '2in 1' concept, we came up with outstanding and unique design of 'Johnnie Walker Shopping Bag' that functions as a shopping bag and present wrapping with ribbon. This responds the market trend with modern lifestyle, in which everything should be unique and convenient.

Whiskey maker Johnnie Walker worked with Bangkok-based design agency, Prompt Design to produce reusable gift packaging that not only looks good, but functions with their customer's modern lifestyle—so convenience was key. With their consumer behavior in mind, Johnnie Walker produced this red, festive, two-in-one packaging that shrinks down to a gift box with yellow ribbon or folds out to a shopping bag with handles.

"This responds to[consumers'] modern lifestyle, in which everything should be unique and convenient."

The result: packaging that inspires giving and makes life easier for the buyer.

Debido al carácter consumista en Tailandia, la gente suele regalar whisky en ocasiones especiales. A partir del concepto de dos en uno, elaboramos un diseño extraordinario y único para la bolsa Johnnie Walker, que sirve como bolsa de la compra y como caja para regalo con un lazo. Esto responde a la tendencia del mercado hacia un estilo de vida moderno, en el que todo debe ser único y útil. El fabricante de whisky Johnnie Walker trabajó con una agencia de diseño de Bangkok, Prompt Design, para producir un envase para regalo reutilizable que no solo fuese bonito, sino que se adaptase al estilo de vida moderno de sus clientes, así que la clave fue que se pudiese reaprovechar. Pensando en el comportamiento de sus consumidores, Johnnie Walker fabricó este envase dos en uno, rojo y alegre que se hace pequeño para transformarse en una caja regalo con un lazo amarillo o se dobla para convertirse en una bolsa de la compra con asas.

«Esto responde al estilo de vida moderno de los consumidores, en el que todo debe ser único y útil».

El resultado: un envase que invita a regalar y facilita la vida al comprador.

Johnnie Walker Gift Wrap

client: Diageo Moet Hennessy Thailand
design agency: Prompt Design
executive creative director: Somchana Kangwanjit
creative director: Orawan Jongpisanpatna
account executive: Pongpipat Jongpisanpattana
designer: Nisachon Thanapatkraiporn
www.prompt-design.com

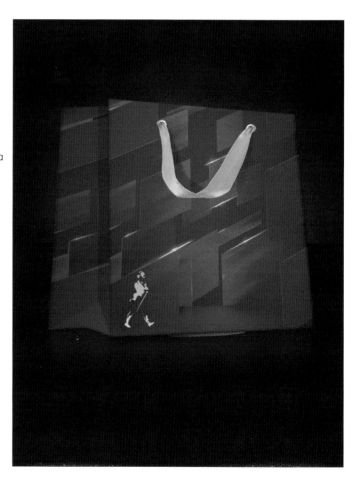

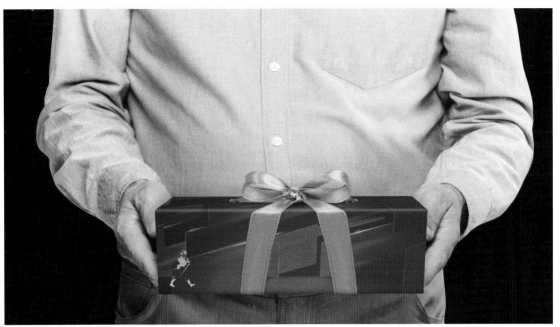

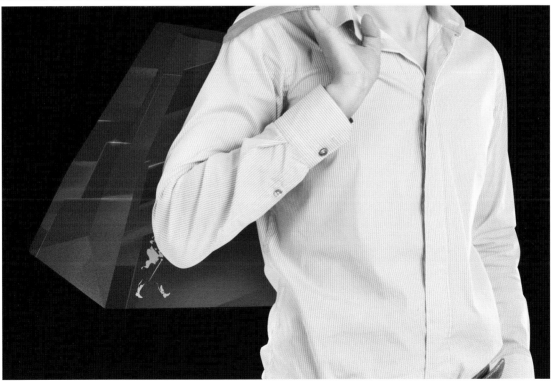

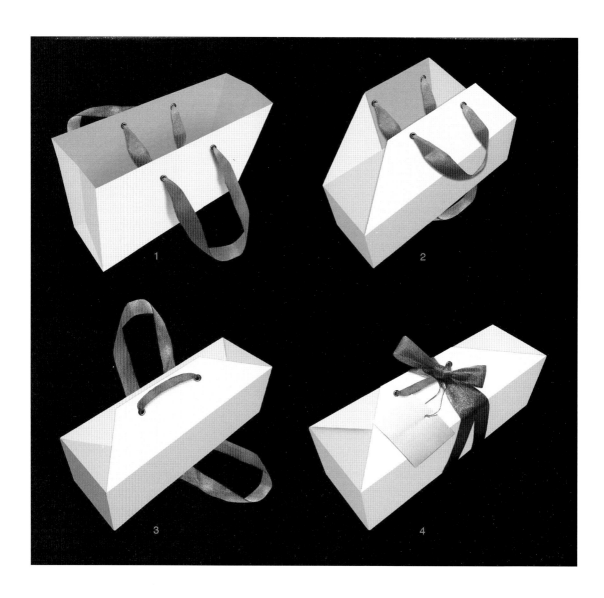

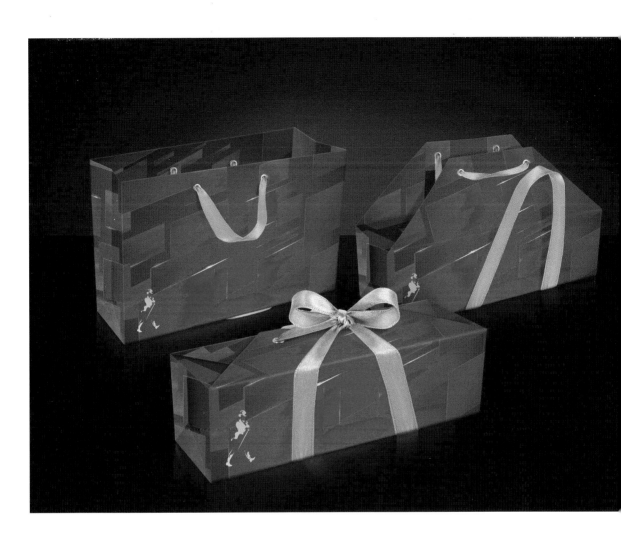

Gran Via 2 shopping centre wanted to create a reusable bag. The idea was not to publicise the shopping centre but promote the slogan "No tenim 2 planetes, cuida'l" (We've only got one planet, look after it). Gran Vía 2 always adds a touch of humour to its publicity, plumping for positive and amusing illustrations. The inspiration for the artwork was based on images of the 70's, more specifically Peter Max and the "Pinball Number Count" video by Jeff Hale for the series Sesame Street. The background for the bag came in three different shades for shoppers to make their own choice. The bag was such as success that the shopping centre decided they wanted a second. Naturally the second had to follow in the wake of the first so the decision was to keep the same characteristics, the same message and the same positive impact but this time in full colour, one black and the other white. A third edition of the bag has also been developed, still in line with it's predecessors in terms of spirit, but original in design and graphics. The choice of a less elaborate illustration was to endorse the legibility of the slogan, featured in the foreground, contrasting with the composition of images in the background. Produced in two colours.

El centro comercial Gran Vía 2 quería crear una bolsa reutilizable. Lo importante no era publicitar al centro, sino potenciar el slogan "No tenim 2 planetes, cuida'l" (No tenemos dos planetas, cuídalo). El Gran Vía 2 siempre utiliza dosis de humor en su publicidad, así que se optó por una imagen amable y positiva. Para desarrollar el artwork la inspiración vino dada por los gráficos de los años 70, concretamente el artista Peter Max y el video "Pinball de números" de Jeff Hale para la serie Barrio Sésamo. Se hizo en tres fondos de color diferentes para que la gente pudiera escoger su preferida. El éxito de esta primera edición de la bolsa llevó al centro comercial a plantearse una segunda. Ésta tenía que continuar la estela de la primera bolsa, así que se optó por mantener las mismas características, el mismo mensaje y la misma carga positiva, pero esta vez a todo color y en dos versiones, una blanca y otra negra. También se ha desarrollado una tercera edición, esta vez, a pesar de seguir manteniendo el mismo espíritu que sus predecesoras, el formato de la bolsa y el gráfico cambiaron. Esta vez se optó por una imagen más sencilla donde se potencia la legibilidad del slogan colocándolo en un primer plano y contrastándolo con el entramado de dibujos de fondo. Se realizó en dos colores.

No tenim 2 planetes, cuida'l

client: C. C. Gran Vía 2
studio: Serse Rodríguez
designer: Serse Rodríguez
illustrator: Serse Rodríguez
www.serserodriguez.com

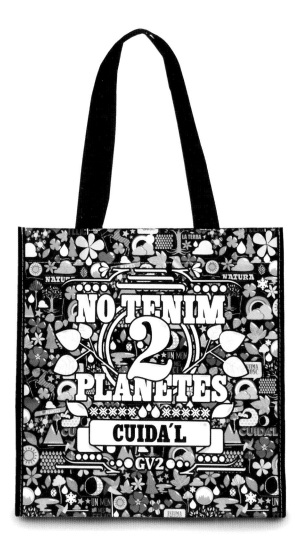

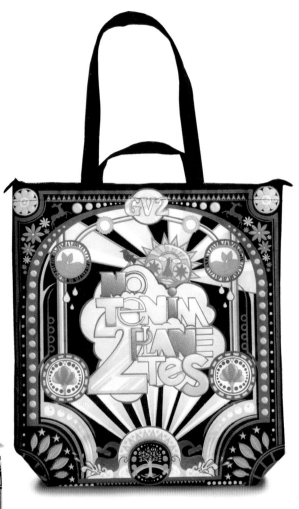
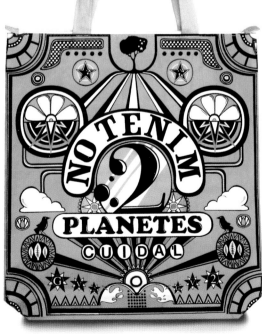

Fabrika – House of Art

client: Fabrika – House of Art
studio: Sophia Georgopoulou | Design
Athens, Greece
www.www.sophiag.com

Logotype and design concept for "Fabrika", a
brand that was created by a group of girls that
create unique, handmade, colourful and fun
jewelry and are based in Athens, Greece.
The logo is inspired by the knots of the jewelry
that are made by coloured threads.
The packaging is also fun and unique since
the jewelry is placed in multi coloured paper
CD cases!

Logotipo y concepto de diseño para Fabrika,
una marca creada por un grupo de chicas
que hacen joyas únicas, hechas a mano,
coloridas y divertidas y cuya sede está en
Atenas, Grecia.
El logotipo está inspirado en los nudos de las
joyas que hacen con hilos de colores.
El envase también es divertido y único, ya que
la joya va en unas fundas de papel multicolor
para CD.

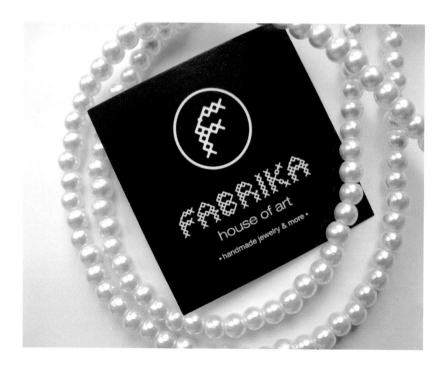

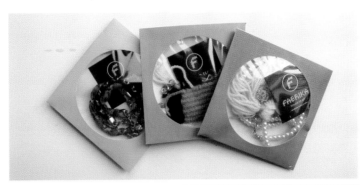

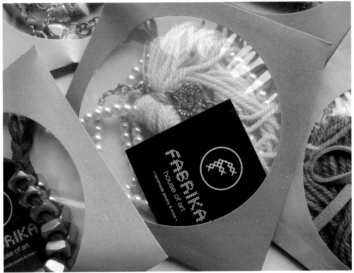

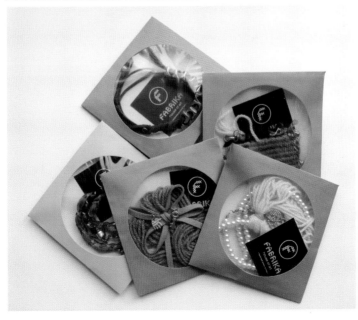

La borsa

studio: G280
creative director: SEO Sunghyeop
Seoul, South Korea
www.ground280.com
www.sunghyeopseo.com

'La borsa' is one of the product came from "Guerrilla Creativo Projcct".

'La borsa', a bag or a shopping bag, is made with a plastic construction fence which we can easily find around the construction area. Even a small amount of damage on the plastic construction fence has to be disposed because only a large area is required. By collecting the used plastic construction fence, the decent parts which are still good enough to be used are cut out to reborn as 'La borsa'. Major supermarkets, such as ESSELUNGA, can give the bag to the consumers for free of charge as a campaign which naturally expose the brand itself and produce great results on promoting.

"La borsa" es uno de los productos de "Guerrilla Creative Project".

"La borsa" es un bolso, o una bolsa para la compra, fabricada con malla plástica para vallas de construcción de las que se pueden encontrar con facilidad en cualquier obra. Aunque una pequeña parte de la malla esté estropeada, solo se necesita una pequeña parte. Al recuperar las mallas de vallas de construcción usadas, solo las partes que aún están en buen estado se cortan y se utilizan para dar nacimiento a "La borsa". Importantes supermercados como ESSELUNGA, ofrecen gratuitamente esta bolsa a los clientes como parte de una campaña que da a conocer la marca y que aporta buenos resultados promocionales.

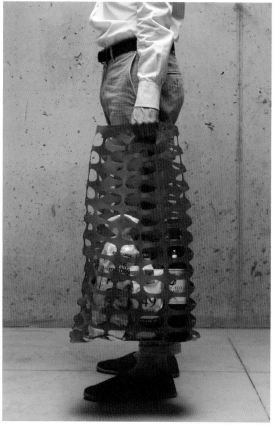
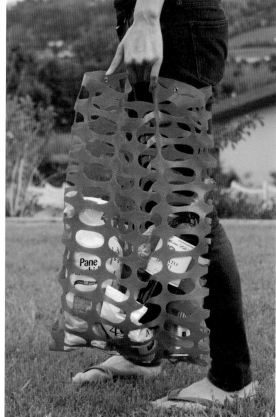

La pasta storia

studio: G280
creative director: SEO Sunghyeop
Seoul, South Korea
www.ground280.com
www.sunghyeopseo.com

"La pasta storia" is a project that mom can read a storybook for their children while they are cooking with this product in the kitchen. This product consists of various pasta and provides simple character making manuals as well as short tales. Parents and their children will make a character together before cooking and parents will be able to tell the stories to their children at the same time. Thus, it helps them to have better communication each other. As a result, it would give them good childhood memories with their parents.

The designer points out that the purpose of this product is to help parents and children to have a good relationship. Generally speaking, family members communicate each other while they are having a meal together. It causes family members to share the memories and life matters. Pasta is an ingredient. It will be cooked and be served as a meal. However, "La pasta storia" is reinterpreted as a memory connections between the family members.

"La pasta storia" es un proyecto en el que mamá puede leer un cuento a los niños mientras estos preparan un producto en la cocina. Ese producto, consiste en diferentes tipos de pasta que representan unos personajes sencillos hecho a mano, así como unos cuentos cortos.

Padres e hijos crean juntos un personaje antes de empezar a cocinar, y de esta forma, los padres podrán contar la historia a sus niños al mismo tiempo. Esto les ayudará a comunicarse mejor entre ellos, y además tendrán un bonito recuerdo de infancia con sus padres. Según el diseñador, el propósito de este producto es ayudar a padres e hijos a mantener una buena relación en general. Los miembros de la familia comunican entre ellos mientras comen juntos, y les lleva a compartir recuerdos y cosas de la vida cotidiana. La pasta es un ingrediente. Se tendrá que preparar y servir como una comida. De esta forma, "La pasta storia" puede interpretarse como la forma de relacionar recuerdos entre los diferentes miembros de la familia.

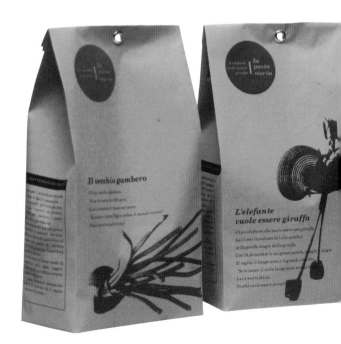

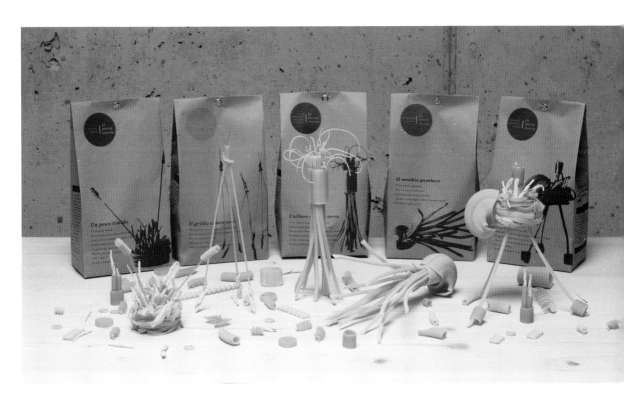

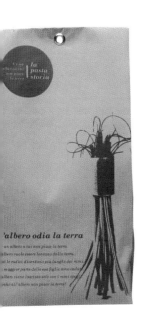

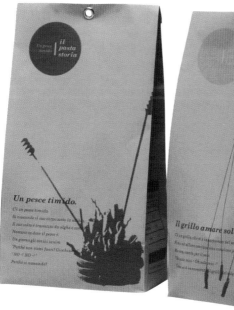

Nate Williams

client: Blue Q
studio: N/A
designer: Blue Q
www.blueq.com

What's black and red all over? This fabulous new design from artist Nate Williams featuring a dark and artsy image splashed with metallic silver. Waterproof and easy to clean, fill it to the brim with everything you need for an afternoon at the grocery store, the beach and beyond. Sweet and fresh and all things that tumble and go round and round. Illustrated by Nate Williams. 8.5"w x 10.5"h x 4"d". 95% recycled woven polypropylene. All bags are made from 95% recycled post-consumer material that includes used grain sacks and plastic water bottles, making it the highest percentage of any woven polypropylene bag on the market. 1% of the sales of all Blue Q bags support the conservation work of The Nature Conservancy, a leading conservation organization working around the world to protect ecologically important lands and waters for nature and people.

¿Qué es negro y rojo por todas partes? Este diseño nuevo y fabuloso del artista Nate Williams, con una imagen oscura y artística salpicada de plata metálica. Resistente al agua y fácil de limpiar, llenar hasta el borde con todo lo necesario para pasar una tarde en el supermercado, la playa y más allá. Dulce y fresco y todas las cosas que giran y dan vueltas y vueltas. Ilustrado por Nate Williams. 8.5 "W x 10.5" x 4 "D". 95% de polipropileno reciclado tejida. Todas las bolsas están hechas con material reciclado del 95%, de material post-consumo, que incluye sacos de grano y botellas de plástico de agua, por lo que es el porcentaje más alto que de cualquier otra bolsa de polipropileno tejido del mercado. 1% de las ventas de todos las bolsa Blue Q son para apoyar el trabajo de conservación de The Nature Conservancy, una organización conservacionista líder que trabaja en todo el mundo para proteger tierras y aguas ecológicamente importantes para la naturaleza y las personas.

Antiplastic Bags

client: Toormix
studio: Toormix
creative director: Ferran Mitjans, Oriol Armengou
designer: Ferran Mitjans, Oriol Armengou, Akio Numa
www.toormix.com

Antiplastic bags is a project Toormix wanted to introduce to manufacturers of traditional products, a market sector opposed to the use of plastic bags as far as possible. Our quest was to discover a resistant, high quality product, one of a kind, with an eye-catching design based on a theme. The project was a joint venture with Kamba Kids, manufacturer of children's clothing and textiles at their factory in Burkina Fasso, where numerous families are employed as part of a project to monitor processes to aid development in this field, thanks to textiles. The design is unique, manufactures in a highly resistant thick fabric with an inside pocket and a "corset" in an African fabric to keep a wine bottle in place inside the bag.

Antiplastic bags es un proyecto en el que Toormix quería aportar al mercado de los productos realizados artesanalmente que evitan el uso desmesurado de las bolsas de plástico. Es por eso que buscábamos un producto resistente, de calidad, único y con un diseño vistoso con una idea detrás. El proyecto lo desarrollamos junto a la marca Kamba Kids especializados en téxtil y ropa para niños que fabrican en una fábrica de Burkina Fasso en donde da trabajo a varias familias dentro de un proyecto que controla los procesos para ayudar al desarrollo de esa zona gracias al téxtil. El diseño es único, con una tela gruesa muy resistente, un bolsillo interior y una "faja" interior de tela africana para ayudar a mantener de pie una botella de vino que vaya dentro de la bolsa.

Bäckerei Koch

client: Bakery Koch
studio: Petra Penz
designer: Petra Penz
Balingen, Germany
www.petrapenz.de

In the course of redesigning the Logo of the bakery, est. 1908, all the corresponding items were newly designed. Next to the overall corporate design focus was put on the packaging items: a recognizable packaging range was required. The client wanted to emphasize the handcrafted products and the high quality but use recyclable packaging at the same time. Bread and buns are packaged in lightweight paper bags, cakes are wrapped in paper and whole tarts are packaged in a box with a real bow – so bringing cake for a coffee invitation is simultaneously bringing a present.

En el proceso de rediseñar el logotipo de la panadería, desde 1908, todos los elementos correspondientes fueron nuevamente diseñados. Todo el enfoque general del diseño corporativo fue puesto en los artículos de embalaje: se requería una gama de envases reconocible. El cliente quería hacer hincapié en los productos artesanales y en la alta calidad, pero utilizando envases reciclables al mismo tiempo. El pan y las pastas se empaquetan en bolsas de papel ligero, los pasteles están envueltos en papel, y las tartas en una caja con un lazo, para así al llevar un pastel a una invitación a café, traemos simultáneamente un regalo.

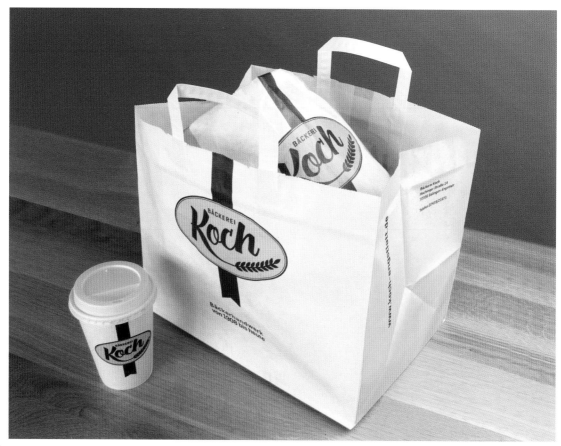

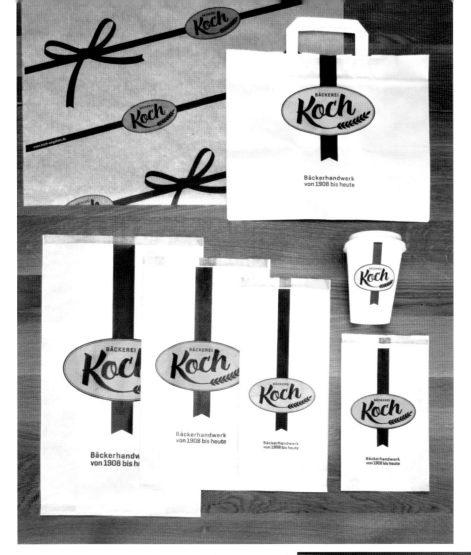

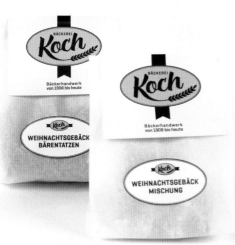

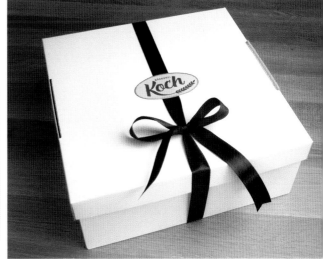

Gourmandiserie

client: Gourmandiserie
studio: Petra Penz
designer: Petra Penz
Balingen, Germany
www.petrapenz.de

The "GOURMANDISERIE" is a producer of high quality ready-made food with excellent taste tor the everyday-gourmet. The aim of the company is to only use regional products, most of them organic, from high quality cultivation and to process these ingredients on the highest possible standard – certainly without preservatives. In addition to the tasteful meals, all products are gluten-free and lactose-free and therefore suitable to allergic persons.

Thus, the packaging should communicate the quality, be recyclable and versatile at the same time: soups, vegetarian dishes, main dishes and desserts all have the same cardboard box but are distinguished by a strong color code at first sight. Plus the boxes allow to see a glance of the product through the die-cut opening.

"GOURMANDISERIE" es un productor de alimentos precocinados de alta calidad con excelente gusto por lo cotidiano-gourmet. El objetivo de la empresa es utilizar productos regionales, la mayoría de ellos orgánicos, desde el cultivo de alta calidad hasta el proceso de estos ingredientes en el más alto nivel posible –sin duda sin conservantes–. Además de ser los platos deliciosos, todos los productos son sin gluten y sin lactosa y por lo tanto adecuado para las personas alérgicas.

De este modo, el packaging debe comunicar la calidad, ser reciclable y versátil a la vez: sopas, platos vegetarianos, platos principales y postres tienen la misma caja de cartón, pero se distinguen por un fuerte código de color a primera vista. Además las cajas permiten ver de un vistazo el producto a través de la abertura troquelada.

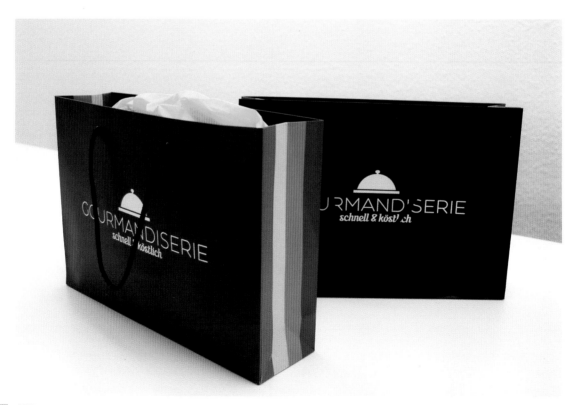

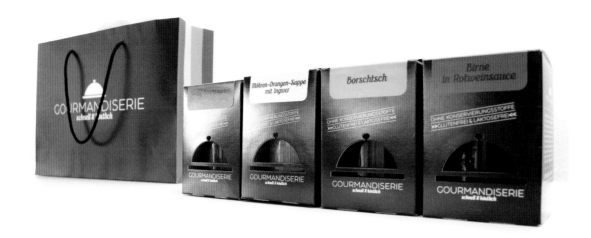

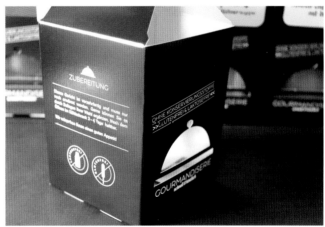

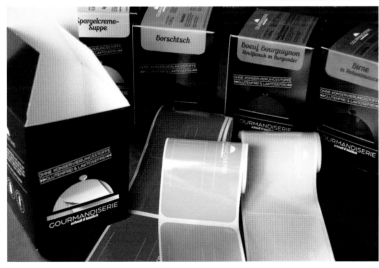

Queens

client: Queens store
studio: Petra Penz
designer: Petra Penz
Balingen, Germany
www.petrapenz.de

A small and classy fashion store, specialized in exceptional pieces wanted to revamp their totes. The female clients reuse the high-end totes until they fall apart – so the goal was to make these even more special and desirable.

Buying and protecting it-pieces and other precious things was communicated on the small and the middle size tote: You would love to lock the bag so your unique pieces are protected. The larger bag was designed more restrained because of it's content which is mostly very expensive and large, e.g. winter coats or other larger pieces. Reaching a certain price range, women don't want to show off while walking through town.

The bags are manufactured in paper, coated and can be reused many times before getting recycled in the dual system in Germany.

Una pequeña y elegante tienda especializada en artículos excepcionales deseaba poner al día sus bolsos. La clientela femenina usa sus bolsos de lujo hasta que practicamente se caen a trozos, por eso el objetivo era convertirlos en objetos aún más especiales y deseables.

A los bolsos de pequeño y medio tamaño se les dotó de un sistema de cierre con el fin de proteger la bolsa y su contenido. En cuanto a las bolsas de mayor tamaño, además de eso, el diseño se hizo más sobrio. La razón, es que al ser más grandes, el contenido probablemente será mas valioso, por ejemplo un abrigo u otro tipo de prenda. A partir de una cierta gama de precios, a las mujeres no les gusta que ciertos objetos llamen demasiado la atención. Las bolsas se fabrican en papel estucado y se pueden reutilizar muchas veces antes de ser recicladas en el sistema dual en Alemania.

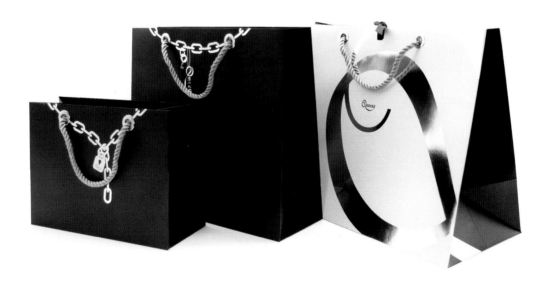

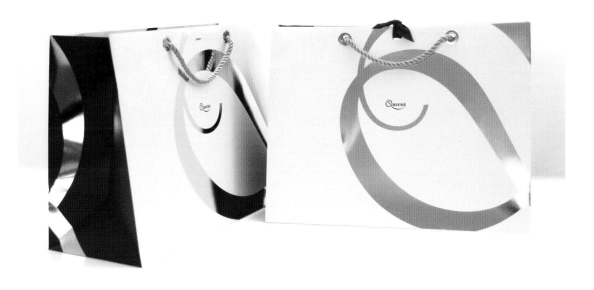

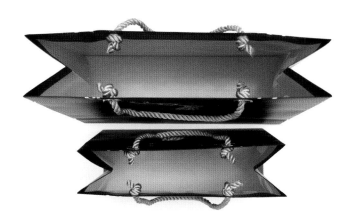

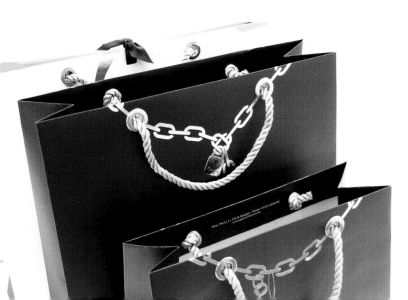

Bad Air Monster Bags

client: Pacific Paint (Boysen) Philippines, Inc.
studio: TBWA/SMP
creative director: Melvin Mangada
art director: Dante Dizon
illustrator: John Ed De Vera, Nolan Fabular
producer: May Dalisay
digital artist: Rusby Gonzales
production house: Christine Mae Enterprise
www.tbwa-smp.com

TBWA/SMP is a Manila-based advertising agency that practices "disruption" as its corporate philosophy. It is a five-time awardee of the prestigious Advertising Agency of the Year Award in the Philippines (2004, 2005, 2006, 2010 4As & 2009 Araw Awards) Its print works for Boysen Paints have won Silver Lions in the Outdoors category at the recently concluded 2011 Cannes Lions Advertising Festival. It is part of the TBWA Network. TBWA is tasked to generate awareness for Boysen Paint's newest innovation, KNOxOUT, an air cleaning paint that breaks down poisonous NOx compound into harmless substance; converting ordinary painted walls into an active air depolluting surfaces. With KNOxOUT Paints, the power to clean the air is now in people's hands. And so TBWA/SMP came up with special bags printed with KNOxOUT paint. Each bag bears a graphic monster reminding its holder that the bag doesn't just carry goods but does good to the environment as well.

TBWA/SMP es una agencia de publicidad ubicada en Manila que práctica la «alteración» como filosofía de empresa. Fueron cinco veces galardonados con el prestigioso Premio a la Agencia de Publicidad del Año en Filipinas (premios 4AS en 2004, 2005, 2006 y 2010 y premios Araw en 2009). Sus trabajos tipográficos para Pinturas Boysen han ganado el León de Plata en la categoría Outdoor del Festival Internacional de Publicidad Cannes Lions de 2011. Es parte de la red TBWA. A TBWA se le encargó suscitar interés por la más reciente innovación de Pinturas Boysen, KNOxOUT, una pintura que depura el aire y descompone el compuesto tóxico NOx en una sustancia inocua, convirtiendo una pared pintada normal y corriente en una superficie descontaminante. Con las pinturas KNOxOUT, el poder de purificar el aire está en manos de la gente y por eso, TBWA/SMP creó unas bolsas especiales estampadas con pintura KNOxOUT. Todas las bolsas llevan un gráfico enorme que recuerda al que la lleva que la bolsa no solo contiene bienes, sino que también hace un bien al medio ambiente.

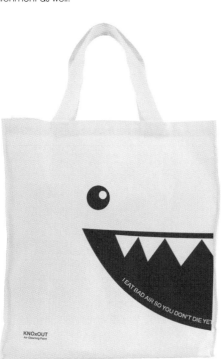

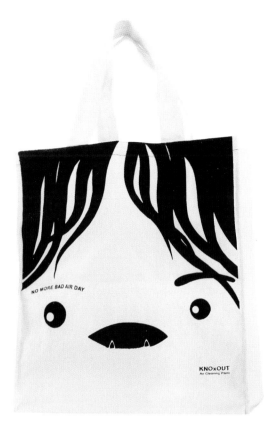

NO MORE BAD AIR DAY

KNOxOUT
Air Cleaning Paint

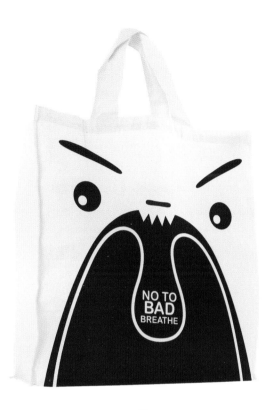

NO TO
BAD
BREATHE

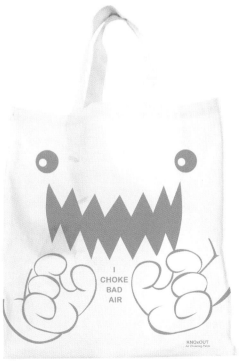

I
CHOKE
BAD
AIR

KNOxOUT
Air Cleaning Paint

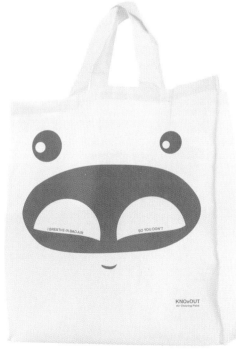

I BREATHE IN BAD AIR SO YOU DON'T

KNOxOUT
Air Cleaning Paint

"They use our pattern print on thick pound of brown paper of yellow via four-color printing. In May, 2011, Filter017 was opened the first entity concept shop. So we release own your style paper bag for shot used. In order to match the overall visual color is black, white, kraft paper color, so the use of kraft paper printed black design."

"Estampamos el dibujo sobre una libra gruesa de papel de estraza de color amarillo mediante una impresión a cuatro colores. En mayo de 2011, Filter017 inauguró la primera tienda de conceptos de entidad, así que lanzamos una bolsa de papel con nuestro propio estilo para un uso breve. Para que se ajustara al color visual general del papel de estraza blanco y negro, se hizo un diseño impreso en negro con el mismo tipo de papel."

Concept shop paper bag

studio: Filter017 Crealive
art director: Enzo Lin
designer: Enzo Lin & Wen Ko & Nick Chen
illustrator: Wen Ko & Nick Chen
photographer: Enzo Lin
brand manager: Hannes Lin
www.filter017.com

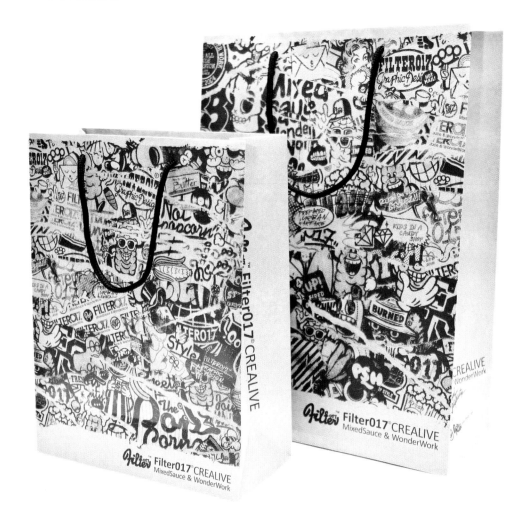

Slow

client: Natura
studio: Thinketing
illustrators & designers: Thinketing
www.thinketing.com

The purpose of this bag was to highlight the prospects of living a less demanding life, basically at a slower pace, allowing every individual to safeguard and take control of their own vital path. The reduced pace has no bearing on negative values, only the advantages of a secure, rational and relaxed approach to life.

La intención de esta bolsa era iluminar la posibilidad de llevar una vida más plena y desacelerada, haciendo que cada individuo pueda controlar y adueñarse de su propio periplo vital. La lentitud no está asociada con valores negativos, sino con los efectos beneficiosos de una actitud pausada, bien razonada y segura.

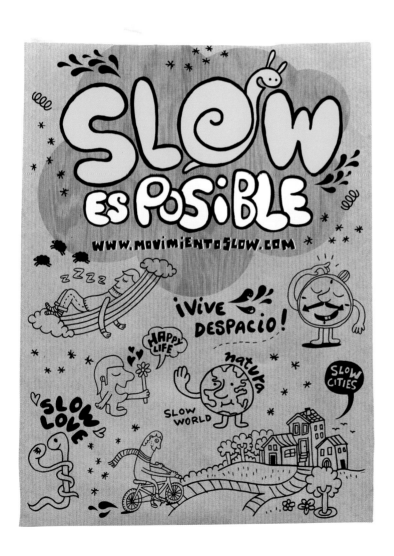

Stop&Go 2008

client: Natura
studio: Thinketing
illustrators & designers: Thinketing
3D development: Hydragrafix
www.thinketing.com

The idea of this bag arose in response to the world's struggle against contamination, global warming, rising sea levels, deforestation, climatic changes... Big words and little action. The final choice, two direct words, Stop & Go ("go" for those who stand up and do their bit); these enormous crisis recreated in just a few letters.

La idea de esta bolsa surge tras la alarma mundial para luchar contra la contaminación, el calentamiento global, el aumento de nivel de los mares, la deforestación, el cambio climático... Grandes palabras y poca acción. Eligieron dos palabras directas. Stop & Go (el "go" para que la gente se levante del sofá y aporte su grano de arena); y recreamos los grandes problemas en las propias letras.

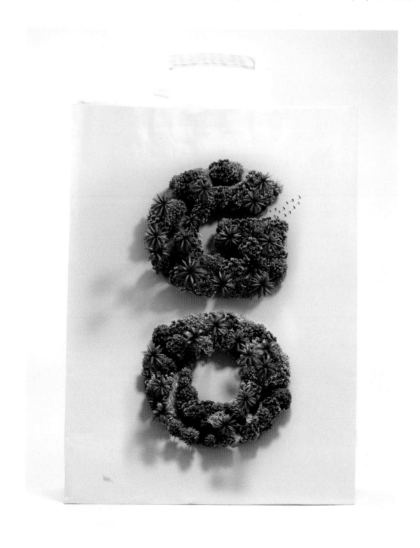

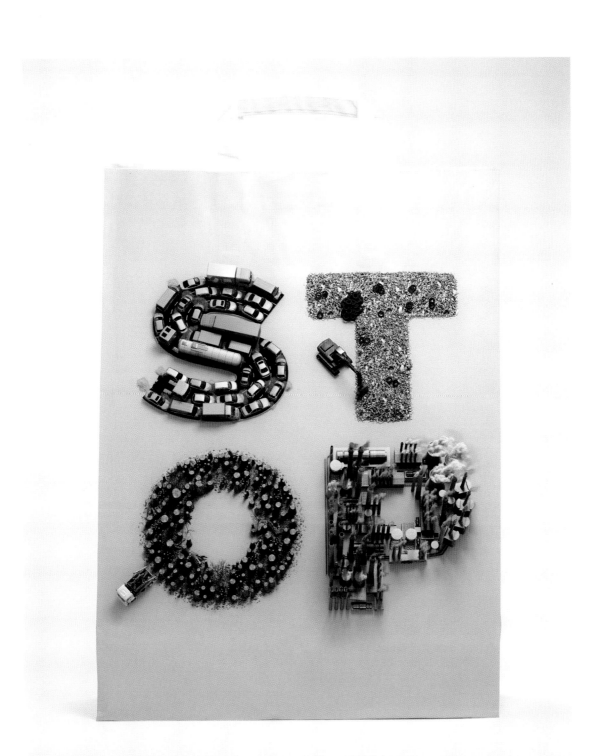

"Your techniques usually begin with a pad of paper and pencils. I first start with concepting, researching, and then creating a mind map or list. Then the start sketching thumbnails, then roughs, then refine and revise the roughs to take them to the comp stage. Depending on the project, the steps will vary. It depends on whether have to develop a rough illustration to a refined stage, or go shoot photos or shoot textures, or begin working with type for a book, etc, but I always begin with paper before advancing to the digital aspects. The objective of this course was to create a fictional food collection line for Williams-Sonoma. The collateral design consisted of labels, packaging, a shopping bag, promotional postcards and a point-of-purchase poster. The key objective in creating my collateral project was to create a distinctive and appealing product line that would evoke a vintage nostalgia through the use of simple typography and hand illustrations. To carry the products and to serve as a means of promotion, I sewed a canvas shopping bag to which I added my product illustrations. To transfer my illustrations on my shopping bag, I used iron on transfers, and then sewed the fabric together. The food collection was inspired by the great Bobby Flay."

"Suelo empezar mi técnica con una libreta y lápices. Primero, empiezo a conceptualizar, investigar y luego creo un mapa mental o una lista. Posteriormente, vienen las reseñas y los bocetos, que después hay que pulir y revisar a fin de llegar a la fase informática. Según el proyecto, los pasos varían. Depende de si hay que desarrollar el boceto de una ilustración hasta la fase de pulir, o si hay que hacer fotos o retratar texturas, o bien, empezar a trabajar con la tipografía de un libro, etcétera. Siempre empiezo con papel antes de pasar a los aspectos digitales. El objetivo de este curso era crear una línea ficticia de alimentos para Williams-Sonoma. El diseño colateral está compuesto de etiquetas, envoltorios, una bolsa, tarjetas promocionales y un cartel que indica el punto de venta. El principal objetivo que tuve en cuenta para llevar a cabo el proyecto colateral fue crear una línea de productos distintiva y llamativa que evocara una nostalgia por lo clásico a través de una tipografía sencilla e ilustraciones hechas a mano. Para llevar los productos y, a la vez, servir como método promocional, cosí una bolsa de lona en la que añadí los dibujos de los artículos. Para transferir mis ilustraciones a la bolsa, planché la calcomanía y la cosí a la tela. La colección fue inspirada por el gran Bobby Flay."

Organic Hills Bags

client: Organic Hills
studio: Erma Miller
designer: Erma Miller
www.heyerma.com

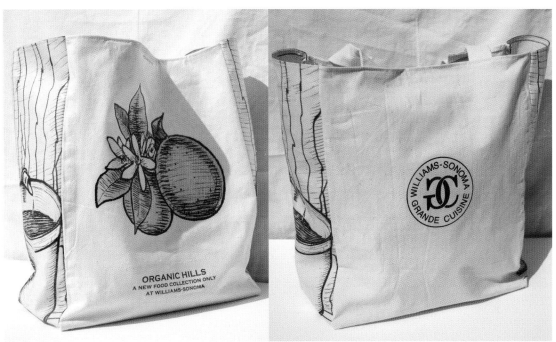

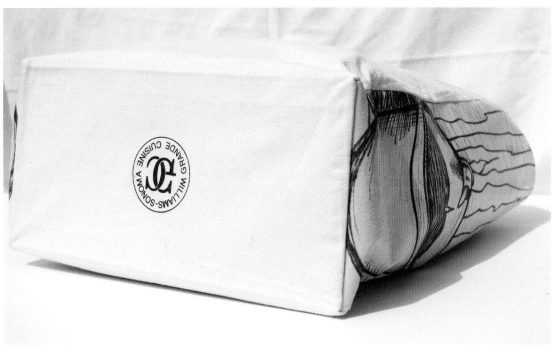